Painting Skies

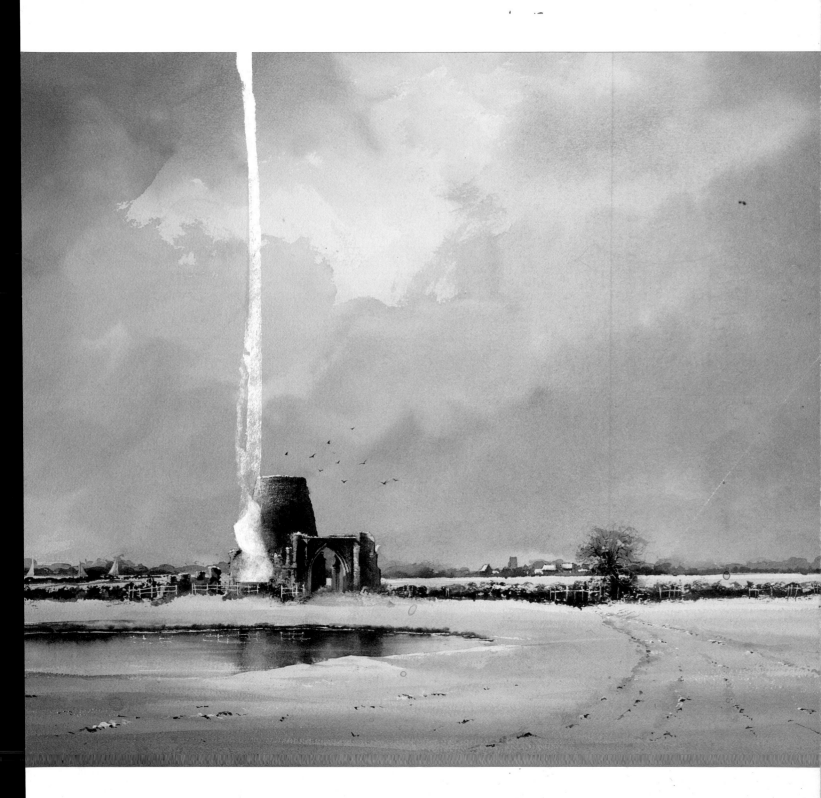

*To Mum and Dad, who would
have enjoyed this.*

Painting Skies

Geoff Kersey

Search Press

First published in Great Britain 2006

Search Press Limited
Wellwood, North Farm Road,
Tunbridge Wells, Kent TN2 3DR

Text copyright © Geoff Kersey 2006

Photographs by Roddy Paine Photographic Studios

Photographs and design copyright © Search Press Ltd. 2006

ISBN 1 84448 129 8

The Publishers and author can accept no responsibility for any consequences arising from the information, advice or instructions given in this publication.

Suppliers

If you have difficulty in obtaining any of the materials and equipment mentioned in this book, please visit the Search Press website for details of suppliers:
www.searchpress.com

Alternatively, you can write to Winsor & Newton, requesting a list of distributers.

Winsor & Newton, UK Marketing
Whitefriars Avenue, Harrow,
Middlesex, HA3 5RH

Publishers' note

All the step-by-step photographs in this book feature the author, Geoff Kersey, demonstrating how to paint in watercolour. No models have been used.

There are references to animal hair brushes in this book. It is the publishers' custom to recommend synthetic materials as substitutes for animal products wherever possible. There is now a large range of brushes available made from artificial fibres, and they are satisfactory substitutes for those made from natural fibres.

Manufactured by Classicscan Pte Ltd, Singapore

Printed in Malaysia by Times Offset (M) Sdn Bhd

Front cover
Shingle Street, Suffolk
68.5 x 49.5cm (27 x 19½in)
The Suffolk and Norfolk coast is rich in subjects for the landscape artist who enjoys skies. I was particularly attracted to the jumble of different shaped buildings, particularly the two Martello Towers.

For the sky I mixed a wash of cobalt and cerulean blue, followed by a thin wash of rose madder and a thin wash of raw sienna. I wet the background, leaving a few dry patches to suggest the tops of clouds. I then laid in the blue wash above the cloud, followed by the raw sienna and rose madder washes brushed into the white area of the cloud itself. This was then allowed to dry before re-wetting and laying in a wash of neutral tint plus a touch more blue in the lower part of the sky. Finally a touch of neutral tint was laid over the blue at the top, taking care to not cover it totally.

Page 1
St Benet's Abbey, Norfolk
71 x 45.7cm (28 x 18in)
I set out one day to find St Benet's Abbey on the Norfolk Broads, having been aware of it for many years from studying the work of Edward Seago. As soon as I approached the subject I could see why it had appealed to so many other artists. It is a fascinating scene with the unique shapes created by the now ruined windmill, built into the remains of the Abbey. I felt that it required a big, dramatic sky. I laid down loose wet into wet washes, then when these had dried, I laid fresh washes over the top, leaving some hard and soft edges. I deliberately made the lower part of the sky quite dark, to contrast with the light on the building and throw up the shapes of the snow-capped roofs and sails in the background.

Pages 2–3
Staffordshire Farm
68.5 x 49.5cm (27 x 19½in)
In this painting of a lonely farm, I used a full imperial sheet of paper and really tried to convey the feeling of isolation amid the vastness of the open sky and land, by deliberately making the little cluster of buildings small. These are still a vital part of the composition, as they give the whole scene a sense of scale and a vital focal point. I have used wet on dry washes, taking care to leave some hard lines to indicate the edges of cloud formations, but softening these in other parts of the sky, to create some variety. I have used the same combination of colours as in the painting of Shingle Street on the cover.

Opposite
Aldeburgh, Suffolk
45.7 x 33cm (18 x 13in)
Aldeburgh is a marvellously atmospheric place on the Suffolk coast, with its beached boats and fisherman's clutter. As I walk on the narrow shingle beach away from the town, I am always reminded of M.R. James' ghost story 'A Warning to the Curious' and almost imagine I can see out of the corner of my eye a lone figure following me. For the sky I mixed three separate thin washes, cadmium red, cobalt blue and neutral tint, before glazing them one over the other on to dry paper, allowing each wash to dry before applying the next. This sky is a little unusual in that it is darker towards the ground, thinning towards the top, to provide a contrast with the pink and white painted buildings and boats.

Contents

Introduction

Because the sky affects all the other main aspects of a landscape painting, I decided at the outset to make this book about much more than just skies. I have endeavoured with each project to include sufficient information to help the reader to continue on from the sky to complete paintings with a coherent design, plus a sense of place and atmosphere.

When I am teaching watercolour landscape painting, I hear myself time and time again saying to students that the sky is the most important aspect of a landscape painting, as it sets the whole mood and atmosphere. I often advise aspiring artists that if the sky has not worked out, it is probably not worth continuing with the painting – better to put that one down to experience and start again. I put this advice into practice myself, and have a collection of abandoned projects to prove it.

I believe painting skies is actually the best way to learn how watercolour behaves. Practising the different techniques explained in this book is an excellent way to become more competent with the medium, learning to control it more effectively and discovering what it will and will not allow you to do. There will be disappointments and many mistakes along the way – this is how we learn – but in my experience, practice always pays off, and the successes will soon start to out-number the failures.

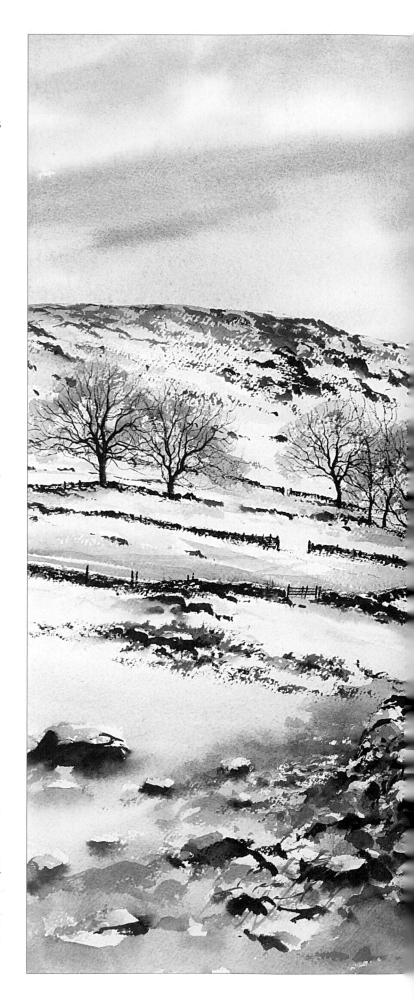

Winter on Baslow Edge

73 x 48cm (28¾ x 19in)

The grit-stone edges, which run for many miles through the Peak District, have provided me with numerous painting subjects over the years. In this scene I laid in a thin wash of quinacridone gold behind the hills, which made the blue/grey shadows and glimpses of white paper along the edge look cold and stark against the afternoon sky. I then introduced a few glimpses of the same colour in the middle distance and foreground to continue this theme.

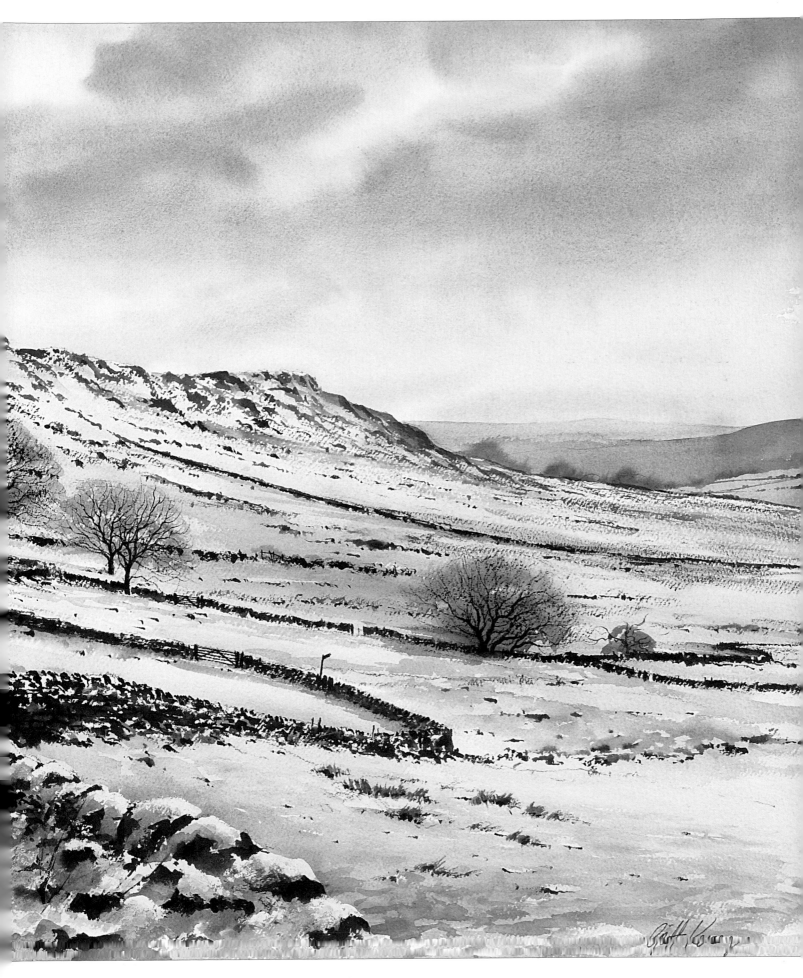

Materials

Choosing the right materials is a very subjective thing, as most artists have preferences based on previous experience. The choice is often influenced by familiarity, in that with products you have become used to, you know more or less what effect you are going to get. I recommend keeping an open mind, however; always be willing to try out a new colour or a brand of paper you have not used before.

Avoid the very cheapest materials, as you get what you pay for, but even good materials do get past their best. I have often noticed people in my classes struggling to depict detail with worn, blunted brushes, or trying to lay a wash with a brush that is too small, thus slowing themselves down and ending up with 'cauliflowers'. You will not be able to mix a good, fluid wash from a dried up tube of paint, and do not struggle with cheap paper that is either too thin or has a poor surface. You can not keep a painting clean and fresh looking if you are mixing your paints in too small a palette without enough separate sections, that has not been kept clean; and old, deteriorated masking fluid is likely to tear your paper when you remove it.

A selection of Hot pressed, Not and Rough papers.

PAPER

I believe that choosing the correct paper has the biggest impact on the finished work, making certain effects much easier to achieve.

There are three basic surfaces, Hot pressed (smooth), Not or cold pressed (medium), and Rough, which is exactly as the name suggests. I prefer in general to use Rough as I use quite a lot of dry brush effects and the texture of the paper really lends itself to this, almost doing it for you. Occasionally I will use Not, particularly if I need a lot of fine lines and detail. Some brands of Not paper do still have a reasonable amount of texture.

The weight or thickness of the paper is also important. Most of the time I use 140lb (300gsm) but I do stretch it to prevent it from cockling. You can avoid stretching by using really heavy papers such as 300lb (640gsm), but I find that the surface changes with the weight and these papers are often double the price.

Lastly you need to consider the make up of the paper. Many cheaper papers are made from wood pulp, which creates a softer, less tough surface than the more expensive, cotton-based papers. These are more resilient, accept masking fluid without it damaging the surface and perform better all round.

Far left: Rough paper. The texture of the paper breaks up the brush marks to indicate foliage. Centre: Not or cold pressed paper. The foliage is still quite convincing, but it appears more solid as there are fewer white spaces. Left: hot pressed paper. With this smooth paper it is very difficult to achieve a broken or textured effect.

PAINT AND PALETTES

In common with many of the professional artists I know, I prefer to use artists' quality tube colours. As the paint squeezed from a tube is already half-way to liquid, it is much easier to make a good, fluid mixture and you do not have to rub away at a pan, blunting your brush. Pans are very useful for outdoor sketching, as they are simpler and less cumbersome to carry, but to get colour from a pan you need to add water, so it becomes more difficult to mix the stronger, richer colours.

In recent years I have noticed an improvement in students' quality paints and if cost is an issue, they make a decent alternative. Artists' quality paints however, do contain a higher ratio of pigment to gum so they tend to go further and last longer. There is also a larger range of colours available in the Artists' quality and some of them do seem to be more vibrant.

My basic palette of colours is: cobalt blue, French ultramarine,quinacridone gold, cobalt violet, raw sienna, rose madder, aureolin, cerulean blue, burnt sienna, cadmium red, viridian, neutral tint, Naples yellow, lemon yellow and light red.

I also have a tube of white gouache for certain effects, but I do not keep it or mix it in my palette as any residue from it can make subsequent mixes grey and chalky. I do from time to time introduce other colours, but because there are only so many wells in the palette, I keep another palette handy for mixing these.

There are numerous palettes on the market, and again your choice will be subject to personal taste. I prefer a folding palette, so that at the end of a painting session, I can lay a piece of wet tissue over the fresh paint and close the lid to seal in the moisture. Once the fresh paint has dried out, it is never as good to work with as when it is in its semi-liquid state, so it is worth taking the time to do this. If I do not paint for a few days, I open up the palette and re-wet the tissue.

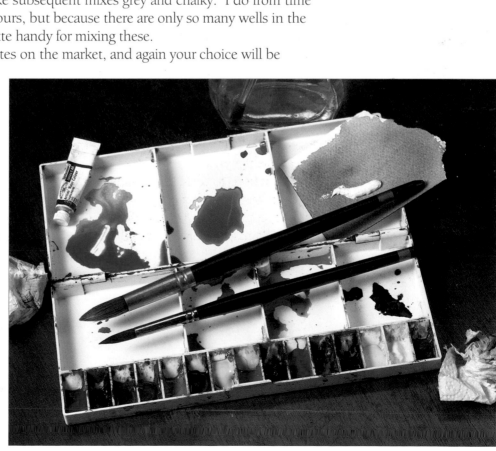

BRUSHES

I favour good synthetic brushes over sable, but I think this is more a case of what I am used to. I find synthetic brushes are springier and therefore return to shape immediately they are lifted off the paper. This makes them easier to control and not prone to going limp. I have tried squirrel mops, hakes and many brushes I have seen being promoted as having an almost magic formula, but I keep returning to basic synthetic rounds and flats. The one exception is the extra large filbert or oval wash brush made from part squirrel and part nylon. I often use this brush for skies as I find it has the best of both worlds: it is very absorbent and its flat profile enables me to cover a large area of paper quickly, without the potential for square shapes in the clouds that can result from a standard flat brush. I also use a rigger or liner/writer brush for fine twigs and branches.

SKETCHING MATERIALS

When it comes to sketching I like to experiment with a variety of materials and I feel more at liberty to work with different media. This is probably because I am not trying to create work for sale or to exhibit – indeed I do not usually show my sketches to anyone. This helps me to work more freely, to draw and sketch to some extent for its own sake. It often happens that you can produce your most creative and spontaneous work when you are not trying too hard.

My main sketching materials are simply a sketchpad, a 2B pencil, a 6 or 8B graphite stick and a putty rubber. I also use water-soluble graphite pencils to create simple monochrome sketches and have recently discovered water-soluble coloured graphite pencils, which seem to have plenty of potential. For more details of my approach to sketching and the materials I use, see the 'Drawing and sketching' chapter on pages 12–13.

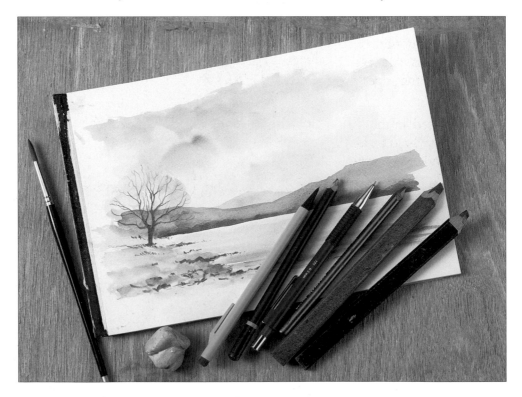

OTHER MATERIALS

Gummed tape, staple gun and painting boards I sometimes use gummed tape for stretching paper, but it does not always stick to the paper's rough surface. You can use a staple gun instead, but only on a tough cotton or rag-based paper; wood pulp papers tear as they contract while drying. It is difficult to remove the staples from MDF board, which has the added disadvantage of being heavy, so I prefer 1.3cm (½in) plywood, which I buy from the DIY store and cut to size myself.

Hairdryer I use this to speed up the drying process during painting demonstrations. When time allows, I prefer to let washes dry naturally.

Ruler Very useful for painting straight lines such as telegraph posts or boat masts. Also for comparing the sizes of objects, to get a feeling for the correct ratios.

Craft knife This is for cutting paper and tape, but it can also make a good tool for scratching out to create grasses or twigs against a dark background.

Natural sponge I use this to give the clean paper a nice, even coating of water.

Soap This helps protect your masking fluid brush. I rub the brush on to a bar of soap before dipping it in the masking fluid, and it acts as a barrier.

Daylight bulb When painting in the studio, I always illuminate my work with two daylight bulbs in angle-poise lamps. These are designed to replicate natural light, and enable me to work in the same light conditions at any time of day and at any time of year.

A daylight bulb.

Stiff brush A stiff bristle brush like the type used in oil painting is useful for carefully removing areas of dried paint to make minor corrections.

Putty eraser This is the best type of eraser for removing graphite marks without damaging the paper surface.

A painting board, gummed tape, paper tissue, hairdryer, water jar, kitchen paper, ruler, craft knife, stiff bristle brush, candle, natural sponge, soap, putty erasers, masking tape, masking fluid and staple gun.

Masking tape This can be useful for masking out a totally flat horizon, or to leave a clean edge all round your finished painting.

Masking fluid In most of my paintings I use masking fluid in the early stages. I use a brand of thin fluid, which is kinder to brushes and the paper surface.

Candle Used for the wax resist technique, as in the painting on pages 62 and 63.

Kitchen paper This can be used for lifting paint to create sky effects.

Water container It is important to have plenty of clean water. I use a couple of large jars and change the water regularly.

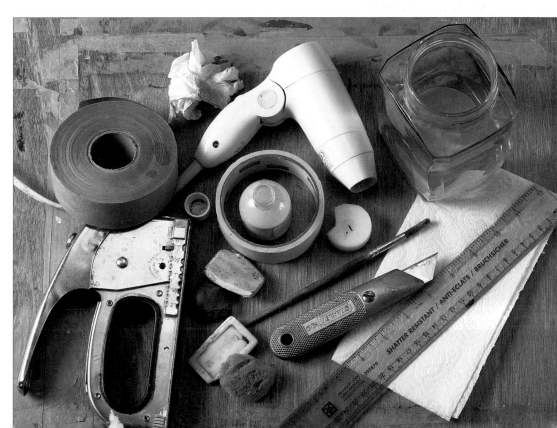

Drawing and sketching

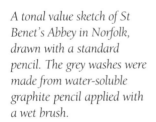

When I sketch outdoors, I do not put much detail in the sky with a pencil, as line is not the best medium for catching the fluid, soft, vaporous effects I am usually trying to achieve. As long as I return to the studio with enough information to work into a finished painting, I can more or less invent the sky based on previous experience, or work from a photograph, possibly with the additional help of a few colour notes.

In all the time I have spent teaching watercolour painting, I have never seen a good painting created from a bad drawing. Even loose, freely painted watercolours need to have a basic draughtsmanship and a sense of perspective and shape.

Unfortunately, for many people attending classes, the painting is the exciting part and the drawing is the necessary but uninteresting bit you have to go through before you can get cracking with the brushes. This virtual fear of drawing is often due to a lack of confidence which can be remedied by practice, and it is for this reason that time spent drawing and sketching is never wasted. Not only will it increase your drawing skills, but even more importantly, it will develop your powers of observation.

It is amazing what you can create using just pencils, paper and a putty rubber, but there is an ever-increasing range of materials that are fun to experiment with.

The drawing below is a tonal value sketch of St Benet's Abbey in Norfolk. I used an 8B water-soluble graphite pencil – some brands refer to this as dark wash – and a standard 2B pencil. I started by sketching in the main shapes in line only, with the standard pencil. I then scribbled a patch of graphite on a separate piece of paper using the water-soluble pencil, and rubbed over this with a wet number 8 brush to create a wash. By varying the amount of water you use, you can create grey washes of varying intensity to paint into the scene, in the same way as you would use hard watercolour pans but without the colour. You are creating a monochrome study in which it is essential to explore the full range of tones from very pale to almost black. You can then tighten this up by adding detail using either or both pencils. With this simple method it is amazing how much life you can get into a simple sketch.

A tonal value sketch of St Benet's Abbey in Norfolk, drawn with a standard pencil. The grey washes were made from water-soluble graphite pencil applied with a wet brush.

12

The colour sketches shown below were done with coloured water-soluble graphite pencils, which I think will prove to be an excellent sketching medium. They are made of water-soluble graphite like the pencil used in the black and white sketch on the opposite page, but they come in a range of colours that become considerably brighter when you introduce water (see right). I have found I can get some interesting effects by using some scribbled patches of colour to create washes, and then sketching directly onto the wet background. This is very similar to the method used in the black and white sketch opposite, but with the addition of colour.

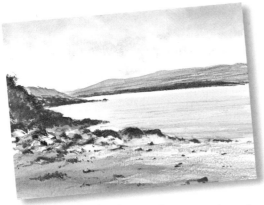
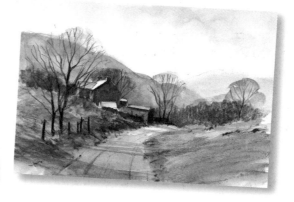

Sketches made using coloured water-soluble graphite pencils.

As a preliminary to a larger painting I often do a half-hour watercolour sketch like the one on the right to get the feel for the subject and try out some colour mixes. This is a 23 x 12.5cm (9 x 5in) evening study. Power station chimneys would not normally be thought of as an attractive inclusion in a landscape but I think in this scene they add a focal point and an opportunity to create a feeling of distance by making them slightly smaller and paler as they recede.

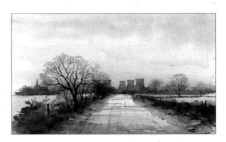

A watercolour sketch.

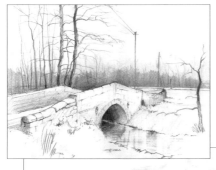

One of the simplest but most effective methods of establishing tonal values is the humble pencil, as used in these three sketches. I favour a 2B as it will give good strong marks if pressure is applied. I like to combine this with an 8B graphite stick, which is made of the same stuff as a pencil but is a lot broader, allowing you to work rapidly, filling in large areas of tone and preserving a feeling of spontaneity.

Using photographs

When I hold an exhibition of work at my Gallery in Derbyshire, I always find it interesting to talk to the visitors. One of the most frequently asked questions is, 'Did you do these paintings on site?' I think people like to imagine the artist out in the wilds, painting directly from nature in all elements. While I think that painting outdoors is a very good discipline and can often give the finished work a feeling of spontaneity, I don't believe it is essential to creating a successful painting. You can still get that feeling of spontaneity and capture the mood and atmosphere of the scene by working from photographs if you bear in mind a few important guidelines.

The main thing to remember is that it is better to work from your own photograph. It is important that you composed the picture yourself and you know the place and are inspired by it. I also think it is a good idea to work on the painting as soon as possible after taking the picture; for this reason, the digital camera is a boon to artists.

The next thing to remember is to interpret the scene, rather than making a slavish copy of it. Take a bit of time at the outset to think what you want to achieve and ask yourself if you are happy with the composition, if not, what changes can you make to improve it? Thumbnail sketches can be useful at this point. Simplification – knowing what to put in and what to leave out – is also important. Interpreting your photographs and turning them into effective paintings takes a bit of practice and experience, so in this chapter I will show you some methods and techniques to make it easier.

On my last visit to the Lake District I was walking along the shore of Derwentwater. The afternoon sky was cloudy, with occasional gaps through which the sun shone, briefly illuminating the rippled surface of the water, creating bright shimmering reflections. It was a perfect opportunity to gather some subject material for paintings. When it came to creating a painting a week later in my studio, I found I preferred the composition in the top photograph, but liked the reflections in the bottom one, so I combined the best of both to create the painting shown below.

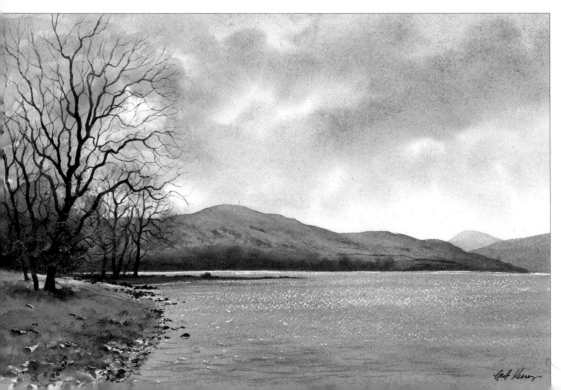

I decided to lighten the scene slightly to avoid too many black silhouettes and I included more detail. Laying in some grey washes, made with cobalt blue mixed with light red followed by cerulean blue mixed with rose madder, created the sky. Before painting the water I gently rubbed over the dry paper with a wax candle. This was then over-laid with the colour mixes used in the sky. The wax resist created the sparkling effect.

The painting below is from a scene I came across on my way to a demonstration for an art club in Norfolk, early one frosty December morning. Conscious of the limited time, I parked the car and quickly took a few photographs; this is a good argument for always having your camera with you. Quick sketches done on site can be an excellent source of material and it keeps up your drawing practice, but I still believe I get more information from the camera.

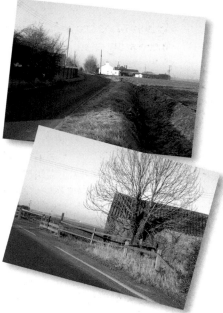

On looking at the photograph (right), I decided to lower the horizon line to give me more sky – always a good feature in Norfolk – and bring the white-washed building, which is the focal point, over towards the right (see Composing from photographs on page 17). This left just a large, dark bush on the left-hand side which I didn't think was very interesting, so I imported a building and an old ivy-clad tree from another photograph I had taken just a few yards further down the lane (see right, below). I always enjoy the opportunity to show orange pan tiles against a blue sky, these colours are opposites and if they are placed together it gives the painting a lift. I used a mixture of Naples yellow and light red for the lower part of the sky and a cobalt blue wash followed by a neutral tint wash in the middle and upper part. Note also how I have darkened the trees to the left of the house to increase the counter-change and draw the viewer's eye to the focal point.

I received an email a few months later from the chairman of the art club I had been visiting, who had come across the finished painting at an exhibition. He recognised it immediately as being very near his home. He knew the place in the painting as soon as he saw it and said how much he liked it, but never mentioned anything about the liberties I had taken and changes I had made. Of course this could be because he was too polite, but I do believe you can get away with some fundamental changes to a scene, so long as you capture the feeling of the moment and essence of the subject. Use your photographs as an inspiration and a starting point rather than a rigid image to copy.

15

In the scene shown below I wanted to paint a wide, panoramic painting. I do not have a camera that can do this so I taped two photographs together. Getting a perfect join does not really matter, as the photographs are not an end in themselves but a means to an end.

I decided to leave out the cars as I felt they obscured any foreground interest, and I added the washing line to introduce a splash of colour and a suggestion of habitation. I do not always add figures but felt that the lone walker helped the composition and led the viewer into the scene. The phone box and speed restriction sign next to the dark green bush were left in, mainly to provide me with a contrasting splash of red. This is the same principle of complementary colours used in the painting on page 15.

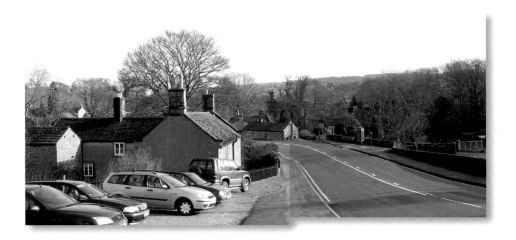

I decided to increase the warmth in the picture by using a soft pink glow made from Naples yellow mixed with rose madder. This was washed over the whole sheet of paper right at the outset to give the feeling that the whole scene is bathed in a milky, wintry, afternoon glow. After this wash was dry, I wet the sky area again with clean water and laid in a wash of cobalt blue mixed with a hint of cerulean blue at the top, fading this down towards the horizon.

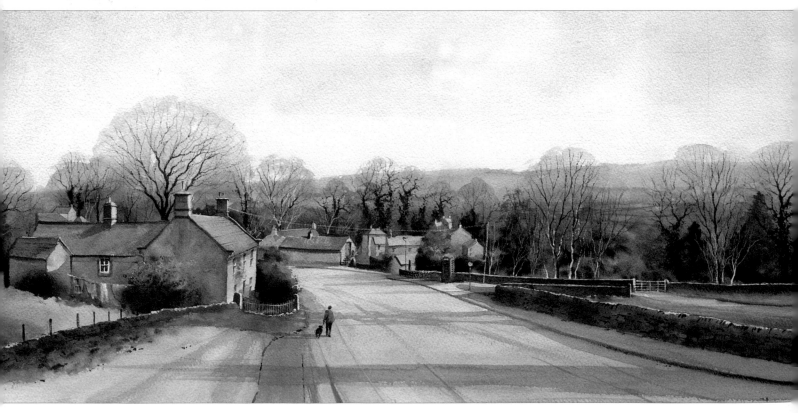

COMPOSING FROM PHOTOGRAPHS

It is always a good idea when composing your painting to remember the rule of thirds. This means that if you divide your paper into three equal sections across and three down, the four points at which these lines cross are excellent places to position your focal point (see Diagram 1). Note how in the example below, a compositional sketch for the painting on page 15, the house, which is the focal point, is positioned at point D. I moved the house there from the position it occupied in the photograph to improve the composition.

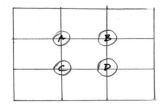

Diagram 1

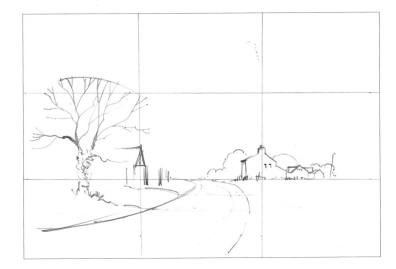

Another aspect of the rule of thirds is the simple L-shaped composition, shown in Diagram 2, right. Note how I have used this in the painting on page 14, the compositional sketch for which is shown below. L-shaped composition has also been used in the painting on page 15.

Diagram 2

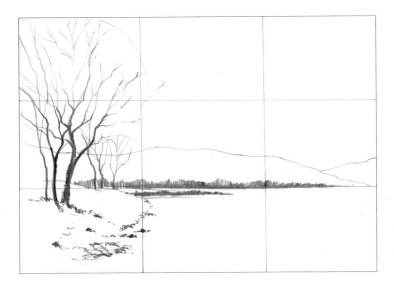

It is a good idea to train yourself to consider these compositional points when you are taking photographs, but remember that the photograph is only the starting point and you can make compositional alterations when you come to draw the scene ready to paint it.

Colour

In order to evoke atmosphere and successfully depict the landscape in different seasons, weather conditions and times of day, you need to have at your disposal a range of colours and tones that you can mix easily from your palette. This is particularly important if you are exhibiting a collection of work, and want to show some variation and breadth. Whilst it is good if the viewing public can easily recognise your paintings as being yours, this should be due to style and interpretation, not because every piece is rendered with the same limited colour formula.

It is a good idea to experiment, but I do not advocate trying to use every colour available. In a quick look through an art materials catalogue recently, I counted twelve variations on blue, twenty-two reds and at least twenty different yellows. It is amazing, however, the range you can create with just a few of these. The suggestions below make a good starting point.

In this chapter I have broken down sky colours into three categories: blues, greys and yellows.

TIP

Do not be afraid to experiment with new colour combinations and permutations.

BLUES

I mainly use three blues: cobalt blue, French ultramarine and cerulean. These all have different properties, but the main difference is in colour temperature: ultramarine is a warm blue, cerulean is cool, and cobalt falls somewhere in between. Look at the example below, which shows how you could use ultramarine at the top of a sky, graduating into cobalt in the middle and finishing with cerulean at the bottom. The idea behind this is that if the sky gradually appears paler and cooler towards the horizon, it helps to create a feeling of aerial perspective, or the illusion of distance.

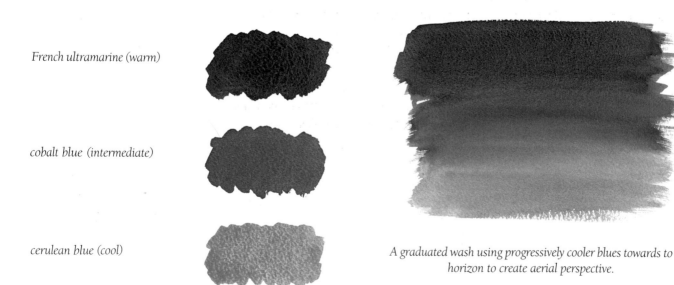

French ultramarine (warm)

cobalt blue (intermediate)

cerulean blue (cool)

A graduated wash using progressively cooler blues towards to horizon to create aerial perspective.

GREYS

There are basically three greys that you can buy ready made – see right. You will see as you work through this book a few examples of skies painted using greys straight from the tube; however by using various mixes of blues and reds/mauves you can create numerous greys from cool to warm, from dark to light. I find a good rule of thumb is to use whichever blue is dominant in the particular sky you are painting to create the greys. Look at the examples shown below.

The big advantage of mixing greys is that you can create many variations by altering the ratio of the colours; for instance the more red/mauve added, the warmer the grey, whereas a lot of blue in the mix will create a cooler effect. In many examples the ingredients separate slightly, almost creating new colours within a colour. Good colours for achieving this effect are ultramarine, cerulean blue and light red (see below).

neutral tint Payne's grey Davy's grey

 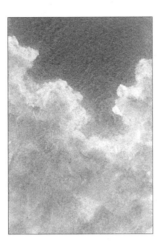

Far left: a cerulean blue sky. The grey is cerulean blue with rose madder. The blue and rose madder separate to create cool and warm greys within the cloud shadows.
Middle: a cobalt blue sky. The grey is cobalt blue with cobalt violet and burnt sienna. There is some separation of colours.
Left: a French ultramarine sky. The grey is ultramarine with light red – a good combination. If the light red dominates, the grey is warmer; if the blue dominates, it is cooler and darker, making a more threatening sky.

YELLOWS

Yellows also play an important part in the sky, as they are often required to take the stark whiteness off the paper and put a hint of a glow into the background. I find Naples yellow very useful as it is more of a cream colour than actual yellow and helps you to avoid inadvertently ending up with a hint of green. One note of caution: Naples yellow contains a lot of white so if it is too strong, it can result in a chalky grey mixture. Raw sienna is another one that is not overtly yellow, especially if you add a hint of red in the form of burnt sienna or light red. Aureolin is excellent for sunsets. I have recently discovered quinacridone gold, a very strong, very transparent yellow/orange, also ideal for putting a glow in the sky especially if you are depicting late afternoon or early evening in late summer or autumn. Look at the examples below: these are just a few of the mixes you can use as part of a sky. Take time to experiment with the different combinations.

raw sienna

raw sienna with a touch of burnt sienna

Naples yellow

Naples yellow and rose madder

aureolin

aureolin and vermillion

quinacridone gold

Techniques

Wet in wet

Always prepare all your mixes before you begin, since once you start to paint wet in wet, everything needs to happen very quickly. If you do not work quickly enough, you will soon find that rather than painting wet into wet, you are painting wet into damp. This causes uneven drying marks, often known as 'cauliflowers'. For this exercise, mix Naples yellow with a little rose madder; cobalt blue with a touch of rose madder to warm it; cobalt blue with a little more rose madder and burnt sienna added to make a warm grey.

Tip

Wash the brush well after using Naples yellow. The white in it will turn a chalky grey if it comes into contact with blue.

1 Wet the background with a sponge and clean water, working horizontally from the top down. There should be no puddles of water, just an even coating.

2 Take the filbert wash brush and pick up the Naples yellow and rose madder mix. Use the side of the brush to float in a tint in the bottom half of the sky to take the white off the paper. Using the side of the brush avoids the effect of a visible repeated shape of the brush point, which would not look natural.

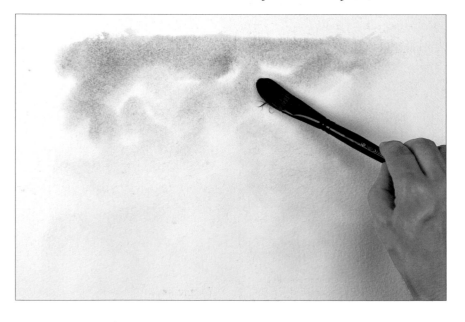

3 Next, pick up the cobalt blue and rose madder mix and paint it across the top, leaving some areas white. These white areas give the impression of cloud and light.

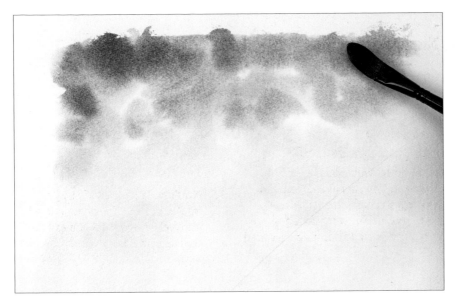

4 Pick up the warm grey mix and paint it in wet in wet to make the sky darker at the top.

TIP

Make sure that your sky is darker at the top, lightening towards the horizon. This helps to create a feeling of distance by means of aerial perspective.

TIP

Your brush may shed hairs onto your painting. When painting wet in wet in this way, it is important to leave the hairs where they are until the painting is dry.

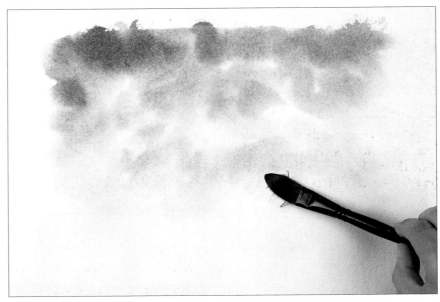

5 Mix the same grey with the Naples yellow and rose madder mix and suggest cloud shadow in the lower part of the sky.

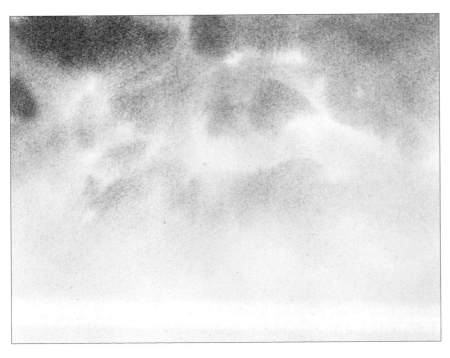

The finished sky.

LIFTING OUT

First make two blue mixes, one warm for the top part of the sky and one cooler. Painting a cooler blue near the horizon helps to create the illusion of distance. The warmer mix is cobalt blue and ultramarine blue; the cooler one is made from cobalt blue and cerulean blue.

1 Wet the whole sky area with a sponge. Take a 2.5cm (1in) flat brush and paint the cobalt blue and ultramarine blue mix from the top down, applying plenty of colour.

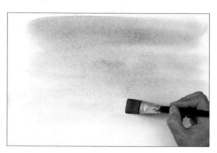

2 Half-way down, change to the cooler blue mix. Towards the horizon, fade out the cool blue by adding clean water.

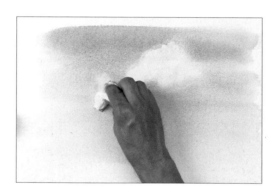

3 While the sky is wet, take a piece of paper tissue and lift out cloud shapes. This needs to be done immediately, as once the paint has started to dry, it will not lift off.

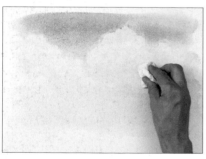

4 Continue lifting out cloud shapes, working quickly while the paint is wet. Vary the shape and size of the clouds to keep them looking natural. You will find that the more pressure you apply, the more paint you lift off. If you apply less pressure to the lower part of a cloud, it leaves a hint of blue, making the cloud look more three-dimensional.

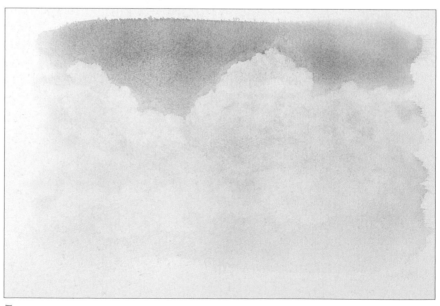

5 When you have finished lifting out cloud shapes, allow the painting to dry. You will often find that you already have a good sky and you do not need to do any more to it. However, you can develop the sky further by following steps 6 and 7.

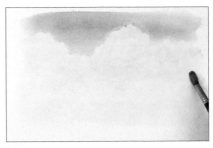

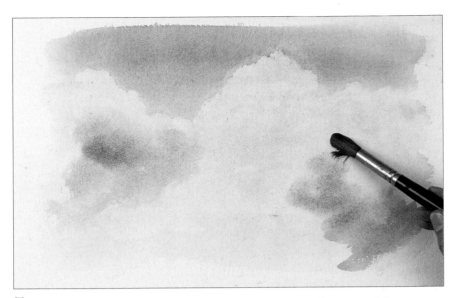

6 Mix cobalt blue with rose madder and a touch of burnt sienna to make a warm grey. Take the no. 16 brush and re-wet one cloud shape, leaving dry paper round the top of the shape.

TIP

You need to wet one cloud at a time to add the cloud shadows, otherwise in the time it takes you to work on one, the others will have dried.

7 Drop in the grey to create a cloud shadow. Working from the centre of the wet area, watch the colour as it spreads slowly into the wet background. You want to achieve soft, diffused shapes, not hard edges. If you see hard edges forming, you can soften these with a damp, clean brush.

The finished sky. This method was used to create the sky in the painting on page 61.

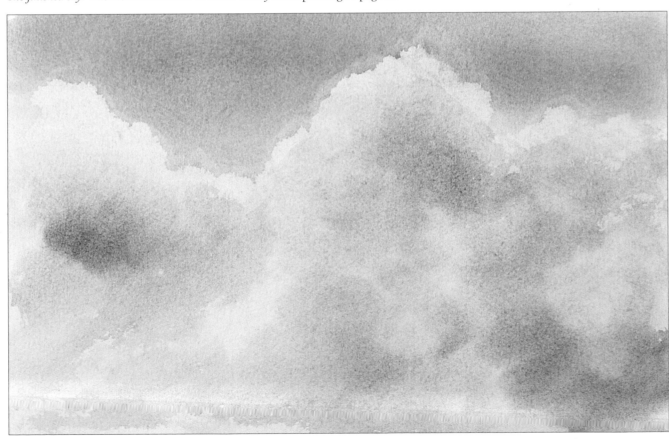

A GRADUATED WASH WITH STREAKS LIFTED OUT

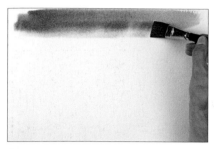

1 Mix ultramarine blue and cobalt blue. Wet the paper with a sponge. Take a 2.5cm (1in) flat brush loaded with colour and begin to paint from the top down with horizontal strokes.

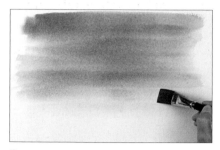

2 Work down the sky area and about two-thirds of the way down, add clear water to fade out the colour.

TIP
Angle the board slightly to ensure that different mixes blend in without creating stripes.

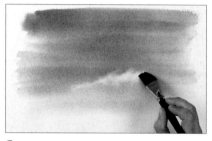

3 Clean the brush and dry it on a tissue. Holding the brush on its side, lift out streaks of cloud from the wet wash, twisting the brush as you go. Lift out the streaks at a slight angle.

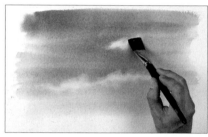

4 Continue lifting out streaks, cleaning and drying the brush as you go to keep the brush thirsty. This is important because if you do not keep the brush clean, you will just be moving the blue around rather than lifting it out.

5 Lower down the sky, make smaller streaks. If the streaks get smaller nearer to the horizon, it helps to create the essential feeling of distance.

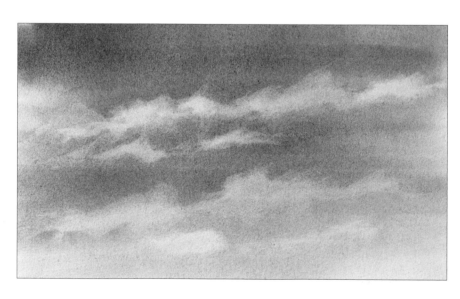

The finished sky.

A WET ON DRY SKY

First prepare three washes: cobalt blue; Naples yellow with a little light red; and neutral tint.

1 Wet the paper using a no. 16 brush and clean water, leaving a few dry spaces which will later suggest clouds.

2 Float the blue wash into the water on the paper and see what shapes emerge. Some of the best effects created using this method are accidental.

3 Clean the brush thoroughly before picking up the Naples yellow and light red mix. Paint this towards the bottom of the painting and in the dry areas. Allow the painting to dry.

TIP

Use thin washes for glazes so that they do not obscure the dried paint underneath.

4 Glaze on another layer of colour with the no. 16 brush and the neutral tint wash. Start at the top left.

5 Use a clean, damp brush to soften in the dark clouds.

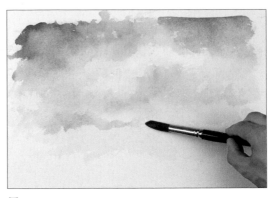

6 Paint more dark cloud at the top right-hand side using the neutral tint wash, then add cloud shadows in the middle and soften the edges using clean water.

7 Paint smaller cloud shapes towards the horizon, still using the neutral tint wash, and soften them in the same way.

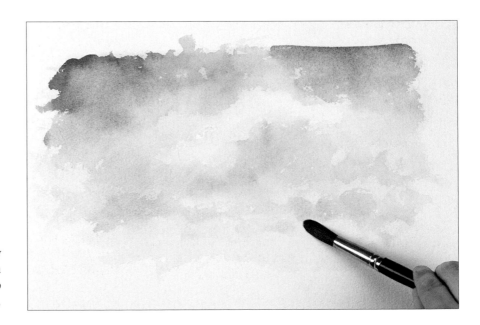

8 Soften any hard edges in the sky using clean water. Make sure the brush is not too wet as it is important not to flood the paper.

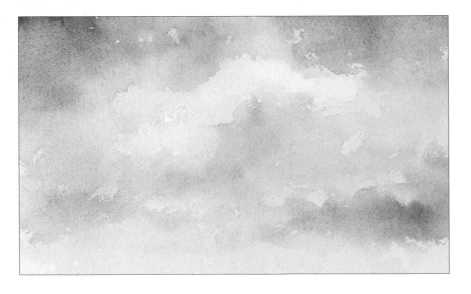

The finished sky. Many of the best effects in this type of sky are accidental, but do not be discouraged if all the accidents are not happy ones – it happens to all of us. Practice is the key.

EVENING GLOW

Prepare the following thin washes before working wet in wet: Naples yellow and quinacridone gold; cobalt blue and rose madder; rose madder; light red; and cobalt blue and rose madder with a touch of light red.

1 Wet the paper first with a sponge and clean water. Use a no. 16 brush to paint the Naples yellow and quinacridone gold mix across the bottom of the sky.

2 Sweep in the cobalt blue and rose madder mix at the top of the sky.

3 Still working wet in wet, paint the rose madder wash in between the yellow and blue washes.

4 Add streaks of light red in the yellow part of the sky.

5 Use a no. 12 brush and light red to drop in clouds.

6 Add more clouds using the light red, making smaller marks as you come down towards the horizon.

7 Pick up the grey mix made from cobalt blue, rose madder and light red, and drop in darker clouds.

8 Add more grey clouds, working quickly wet in wet.

9 Use the tip of the brush to make smaller marks lower down the sky.

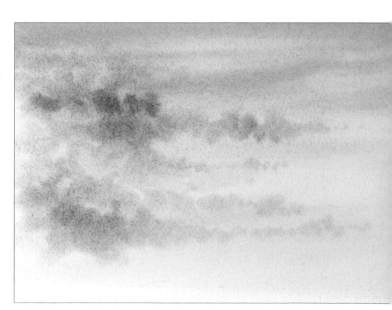

The finished sky.

A STORMY SKY

Mix washes of aureolin and burnt sienna for a golden glow; cobalt blue
and rose madder for purple; and neutral tint with a touch of rose
madder for a warm grey. Also prepare a wash of sepia and one of
cobalt blue.

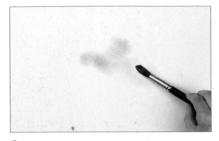

1 Thoroughly wet the paper. Take a
large filbert brush and paint a patch of
warm glow in the middle.

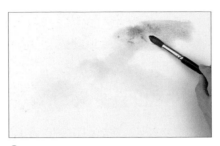

2 Clean the brush and introduce
purple from the top, leaving some white
paper. Allow the colours to blend.

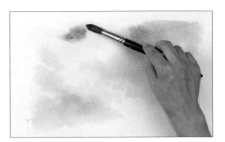

3 Add a touch of cobalt blue at the
top of the sky.

4 Paint in a little neutral tint and rose
madder from the top two corners to
frame the light in the middle.

5 Add sepia for very dark clouds,
allowing the washes to mix on the paper.

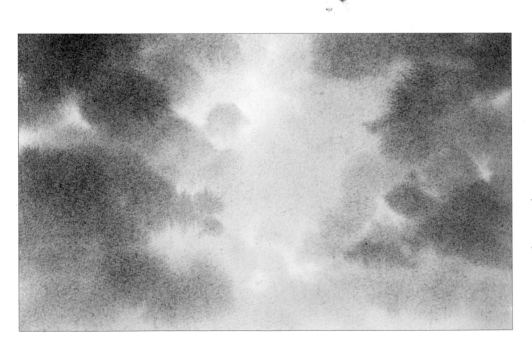

*The finished sky. The strong
wet into wet washes in this
sky produce a dramatic
effect, but do not apply paint
for too long, or you run the
risk of making it too dark.
The drama of this sky comes
from the contrast of light
against dark. Look at the
painting on page 72 to see
how this dramatic contrast
has been carried through into
the landscape.*

A SUNSET

Prepare washes of cobalt blue and rose madder to make purple; aureolin and burnt sienna to make orange; cobalt blue; and cobalt blue, rose madder and burnt sienna to make grey.

1 Wet the paper with a sponge. Use a no. 16 brush and the orange mix and paint in streaks up to about half-way up the sky, at a slight angle.

2 Add purple streaks higher up, then cobalt blue at the top right.

3 Paint the grey in from the bottom right of the painting.

4 Add more grey across the centre of the sky in slightly angled streaks.

5 Take a 2.5cm (1in) flat brush, dip it in clean water and dry it on a tissue, then lift out streaks.

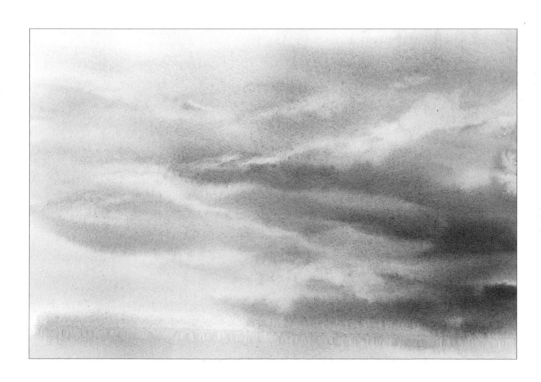

The finished sky.

29

Clear Sky in Winter

I came across this ruined old barn on a winter morning's walk and knew immediately I had found a potential painting subject. I went back again the following spring and it had been demolished, so I was glad I had taken some photographs and done some sketches while I had the opportunity.

I particularly liked the crisp, clear blue sky and the way these sky colours were reflected in the shadows. I considered putting a snow-covered roof on the barn but I quite liked the dilapidated look. I think it could have been painted successfully either way.

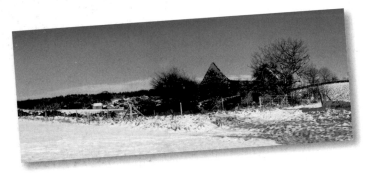

I took two photographs of the scene and taped them together to use as reference for the painting.

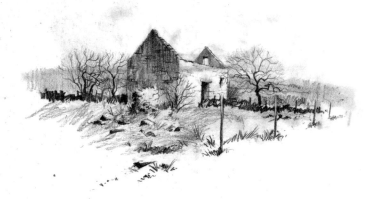

The preliminary sketch.

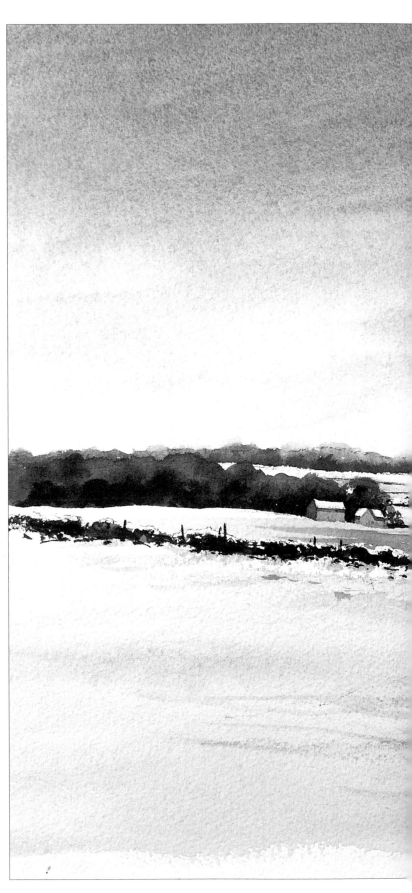

The finished painting.

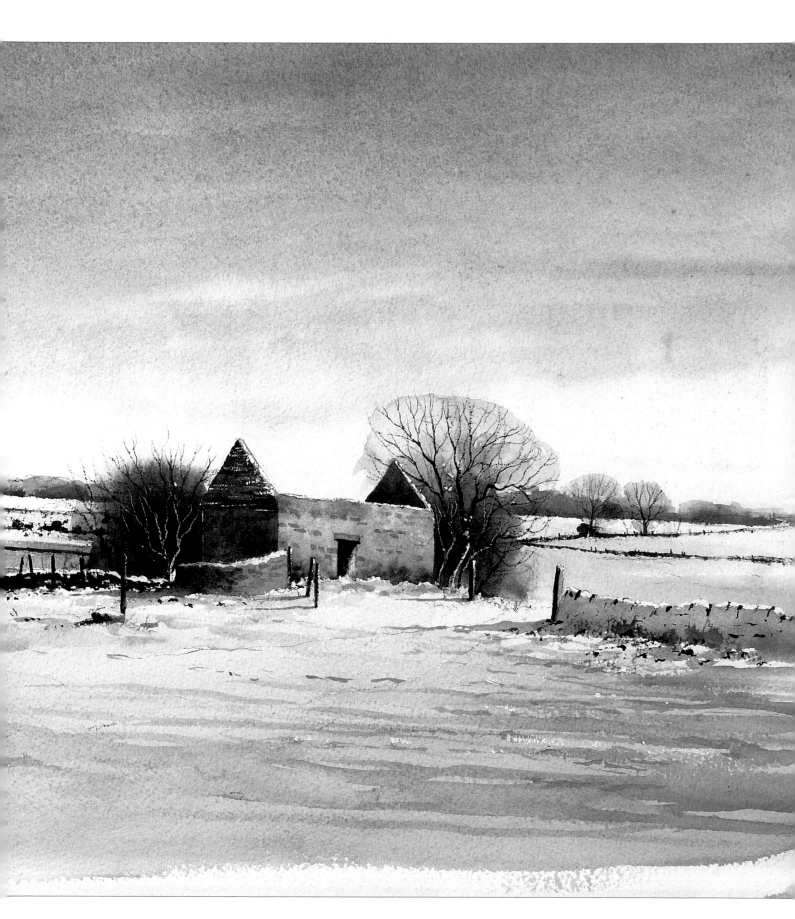

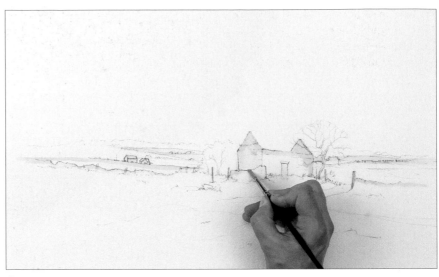

1 Draw the main outlines of the scene. Apply masking fluid to preserve the white of the paper for highlights: round the old barn, on the dry stone wall, the tree trunk, the fence, the distant fields and the snow on the left-hand building.

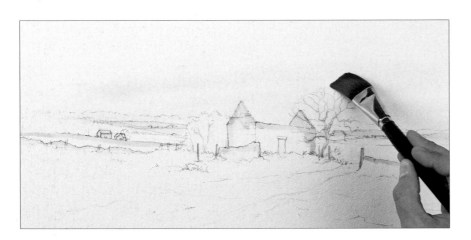

2 Always mix your sky washes first when you are going to be painting wet in wet. In this case, make washes of ultramarine blue and cobalt blue with a touch of rose madder; cerulean blue with a touch of cobalt blue; and Naples yellow with a hint of cadmium red. Wet the whole sky area, down to the horizon and the masked buildings. Start with the lightest colour, the pale pink, and paint streaks of it at the bottom of the sky, going slightly uphill towards the right, with a 2.5cm (1in) flat brush.

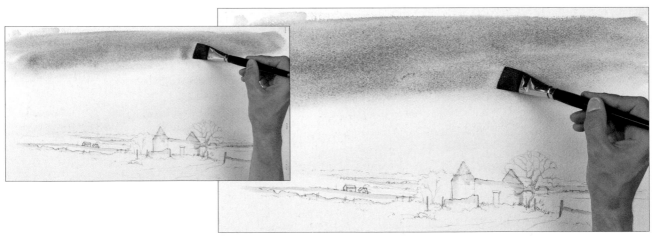

3 Wash the brush, then pick up the ultramarine, cobalt blue and rose madder wash and paint it in strokes across the paper, sloping slightly up to the right. Continue the strokes from the top downwards. Then, without washing the brush, pick up the cooler mix of cobalt and cerulean blue and paint this in the same way lower down the sky. Using a cooler blue towards the horizon helps to create aerial perspective in a sky.

4 As the blue wash reaches the pink wash near the horizon, break up your brush strokes so that the blue drifts into the pink. Allow the painting to dry.

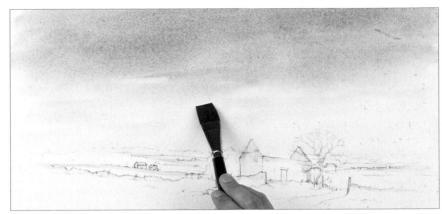

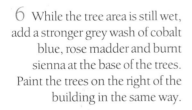

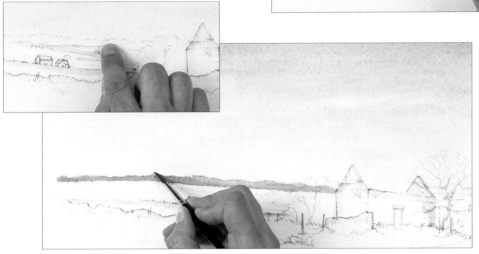

5 Once the sky has dried, use a clean finger to remove the masking fluid from the distant fields, leaving it on the buildings and the tree. Mix cerulean blue and rose madder to make a soft grey and paint the distant trees using a no. 6 round brush. Bring the colour down to the line where the trees meet the snow-covered field. Then use a damp, clean brush to soften the top edge of the tree area, to accentuate the feeling of distance.

6 While the tree area is still wet, add a stronger grey wash of cobalt blue, rose madder and burnt sienna at the base of the trees. Paint the trees on the right of the building in the same way.

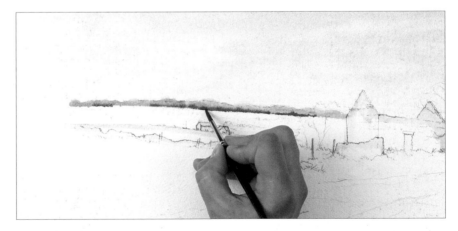

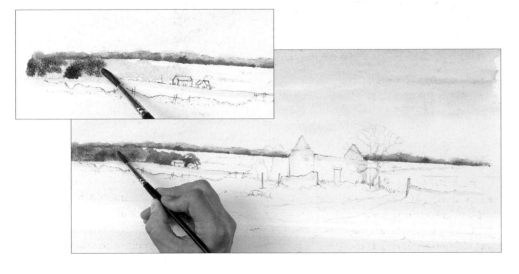

7 Wet the woodland area on the left with clean water and drop in more of the stronger grey. Mix a wash of raw sienna and burnt sienna and drop it in wet in wet to warm the woodland area.

33

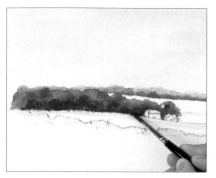

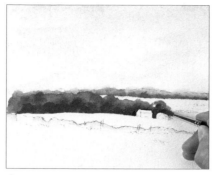

TIP

It is not easy to paint accurate shapes with masking fluid, but you can always do a bit of tidying up once you have removed it.

8 Drop in more of the cobalt blue, rose madder and burnt sienna mix wet in wet near to the masking fluid at the base of the trees.

9 Remove the masking fluid from the field's edge and the buildings on the left of the painting. If necessary, tidy up the edges of the buildings using a no. 6 brush and the same dark paint mix.

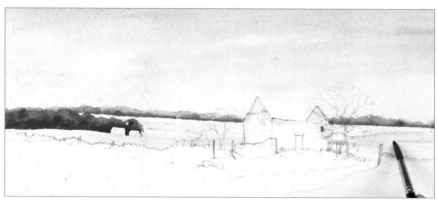

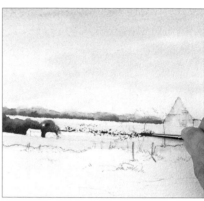

10 Mix two thin washes based on the sky colours, one of cerulean blue for cooler, distant shadows and the other of cerulean blue and rose madder for shadows nearer the foreground. Take the cooler wash and a no. 10 brush and paint the distant shadows, making sure your brush strokes follow the shape of the land, and leaving some white paper showing.

11 When the shadow washes have dried, mix a mid-brown wash of burnt sienna and cobalt blue. Take the no. 6 brush, pick up some of the wash then dry the brush a little on paper tissue. Hold the brush on its side and drag it over the surface of the paper, using the dry brush technique to suggest dark patches showing through the snow.

12 Continue working on the same area of the distance on both sides of the buildings. Still using the no. 6 brush and the same mix, paint thin lines to suggest dry stone walls. Dab in distant trees and bushes using thick paint and the dry brush technique. Suggest fence posts.

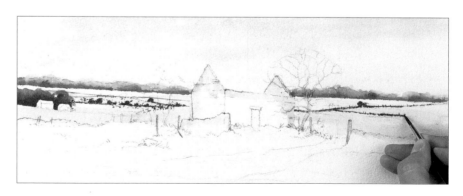

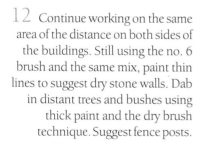

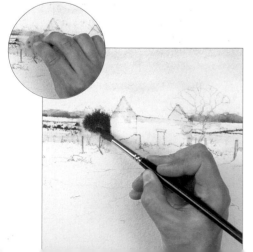

13 To paint the tree to the left of the old barn, fade the distant bushes and walls with a damp sponge. Wet the area with clean water, then drop in the mid-brown mix with a no. 8 brush and watch it spread.

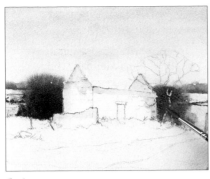

14 Mix a rich, dark brown from ultramarine blue and burnt sienna and, still using the no. 8 brush, drop it in to the tree on the left of the barn while it is still wet, near the ground. Then wet the area of the bush on the right. Drop in the dark brown first, then raw sienna and burnt sienna where the light catches the winter foliage.

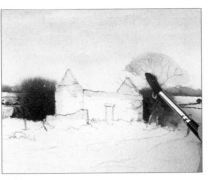

15 Water down the raw sienna and burnt sienna mix and, using the no. 8 brush, paint in the shape of the tree on the right.

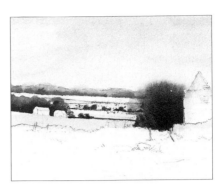

16 Paint a dry stone wall on the left of the barn using the dark brown mix, and add bushes.

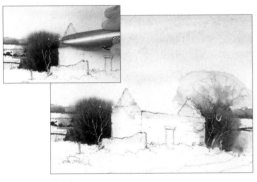

17 Before the paint is dry, scratch out branches in the bushes using a craft knife.

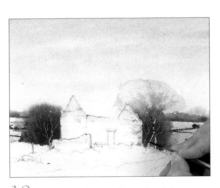

18 Remove the masking fluid from the tree on the right and drop in raw sienna and burnt sienna using the liner/writer brush.

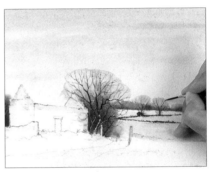

19 Continue the branches where they need to look dark against the light background, using a mix of ultramarine blue and burnt sienna. Water down the mix and paint in branches in the more distant trees.

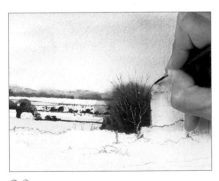

20 Add branches coming out of the bush on the left, continuing the scratched out lines, still using the liner/writer brush.

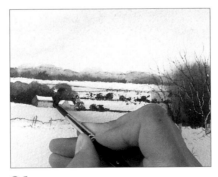

21 Paint the walls of the barns in the distance using raw sienna and burnt sienna and the no. 6 brush. Leave white paper to suggest snow on the roofs. Paint the shadows under the eaves and the shadowed walls using a mix of cerulean blue and rose madder.

22 Shadow the field behind the barn with cerulean blue, up to the masking fluid. Allow the painting to dry.

23 Rub off all the remaining masking fluid. Paint the barn with a mix of raw sienna and burnt sienna using the no. 12 round brush. While the paint is still wet, drop in a mix of aureolin and cobalt blue to suggest moss.

24 Drop in cerulean blue and rose madder wet in wet, then a dark mix of burnt sienna and ultramarine blue, particularly around the bottom of the barn. Use a paper tissue to dab the wet paint, suggesting the texture of stonework.

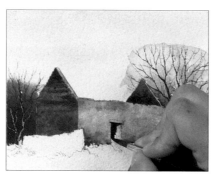

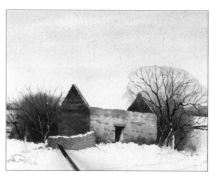

25 Make a shadow mix of cerulean blue and rose madder and paint the left-hand side of the building with the no. 6 brush. Drop in burnt sienna at the bottom, wet in wet, to suggest reflected light.

26 Shadow the gable end on the right with the same shadow mix and a no. 4 brush. Add darks to the left-hand side of the building and paint in the open doorway with ultramarine and burnt sienna.

27 Use the no. 4 brush and a watery mix of burnt sienna and cobalt blue to suggest stones on the front of the building. Then paint the little wall with a mix of raw sienna and burnt sienna and the no. 6 brush. Drop in the shadow colour on the left and blend it in to suggest the curved shape.

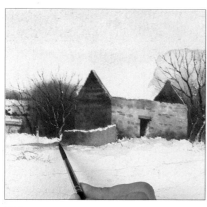

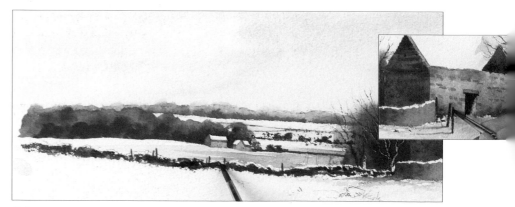

28 At the furthest point of the curved wall, add burnt sienna and ultramarine blue. Then paint a cast shadow from the wall using the shadow mix of cerulean blue and rose madder.

29 Make two strong, thick washes, of raw sienna with burnt sienna and burnt sienna with ultramarine blue. Use the no. 4 round brush to paint the dry stone wall with the lighter wash, leaving white at the top to suggest snow. Then with the no. 6 brush paint in the darks with the darker mix. Add fence posts and cast shadows with the no. 4 brush.

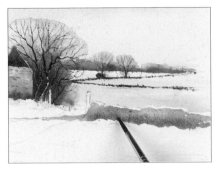 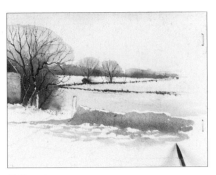

30 Use the no. 6 brush to paint the snow-covered wall on the right with cerulean blue and cobalt blue. Then drop in a touch of cerulean blue and rose madder.

31 Add touches of shadow in front of the wall to suggest uneven snow. Soften the shadows in places with clean water. Leave some harder lines for variety.

32 Paint the fence post using raw sienna mixed with burnt sienna. When it is dry, shadow it with burnt sienna and ultramarine blue.

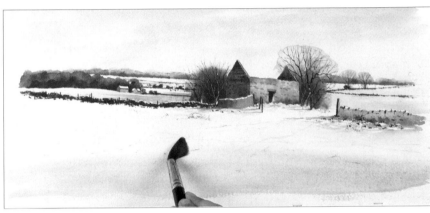

33 When the shadows are dry, use burnt sienna and ultramarine blue to add marks suggesting stones showing in the snowy wall and beneath it in the snow. Then suggest grass at the foot of the wall using burnt sienna and raw sienna.

34 Wet the whole foreground with clean water. Paint in the colour of shadowed snow using cerulean blue and rose madder and the no. 16 brush. Allow to dry.

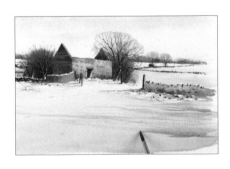

35 Use the no. 8 brush and cobalt blue mixed with cerulean blue to paint shadows cast into the painting from the right-hand side.

36 Paint smaller, slightly stronger marks in the snow on the right, suggesting uneven ground.

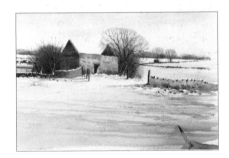

37 Finally add touches of white gouache on the tops of walls and posts and in trees. Also add dark fence posts and stones for contrast.

TIP

Use white gouache neat. If you dilute it, it is not sufficiently opaque.

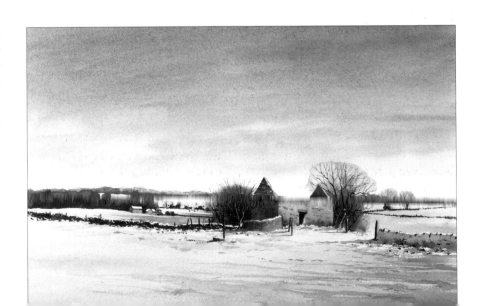

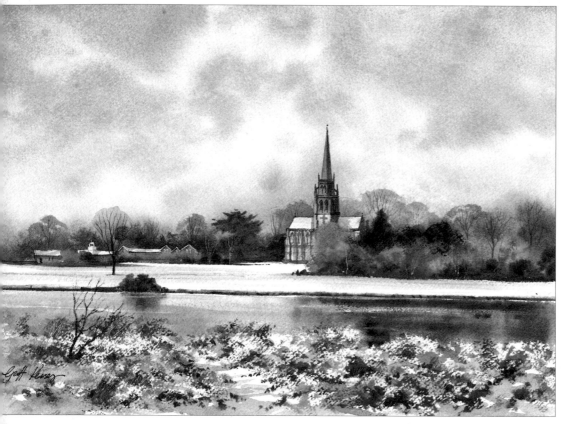

Clumber Park, Nottinghamshire

31 x 23cm (12¼ x 9in)

For the sky in this scene I mixed cerulean blue and rose madder. When these two are mixed, they tend to separate on the paper, which I think has been quite effective here, as it gives a pink/purple glow in the middle and lower part of the sky. I repeated the sky and foliage colours by dropping them into previously wet paper to create the reflections in the river. When the river had dried I lightly brushed some white gouache over it to indicate movement and slight ripples.

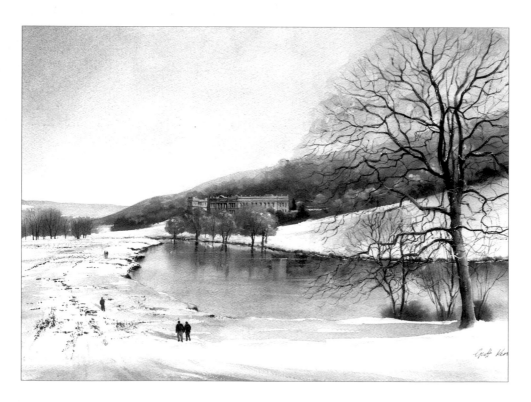

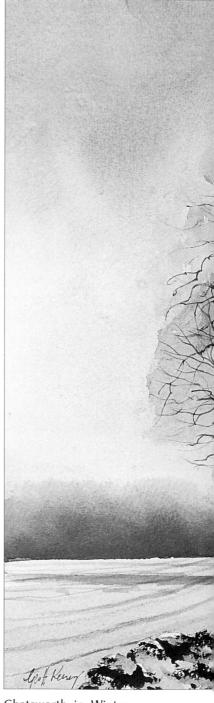

Chatsworth in Winter

38 x 29cm (15 x 11½in)

In this painting the clear blue from the sky is echoed not only in the shadows on the snow but also in the reflections in the water. I used a mixture of cobalt blue and cerulean blue to create a crisp, clean look. Note the area to the right of the house where I have left stark, white paper next to the dark grey/brown background to create an area of maximum contrast.

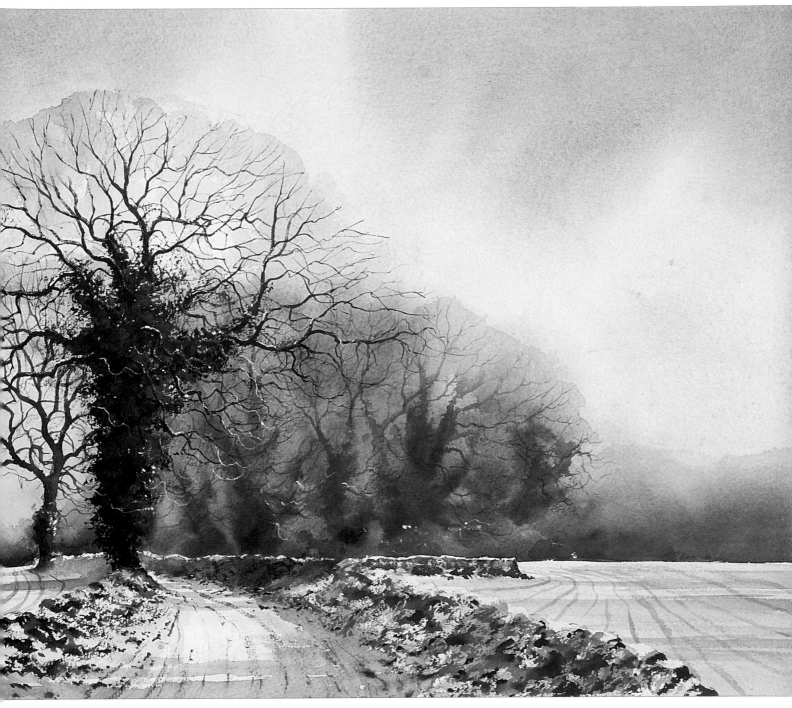

Lane in Winter

65 x 42.5cm (25½ x 16¾in)

I painted this simple but atmospheric scene from the sketch shown on page 13, bottom left. The distant and middle distance trees were indicated wet-into-wet to give them a misty, indistinct look, which helps to push them into the background, creating the illusion of depth. The sky was painted with four separate washes: cobalt blue; cobalt blue mixed with light red; Naples yellow with Indian yellow; and a light wash of neutral tint. These were then floated into a wet background using a 3.8cm (1½in) flat brush. Note how the cobalt blue and light red washes are repeated in the shadows, to give the finished work harmony.

Cloud Shadows

I live just a few miles from Chatsworth Park in Derbyshire, the setting for this painting. It is a very popular subject with both painting buyers and artists, so it is a challenge to find new angles and views. When I chose this composition, I was attracted to the three trees on the right. I liked the way these got progressively smaller, leading the viewer's eye into the scene. I have used the same purple/grey mixes from the sky to place shadows across the land. This not only gives the painting some continuity, but the directions of the shadow brush strokes desribe the contours of the land.

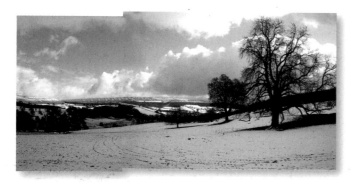

The reference photographs for this painting.

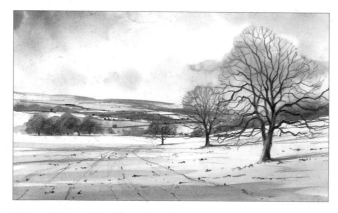

The preliminary sketch.

The finished painting.

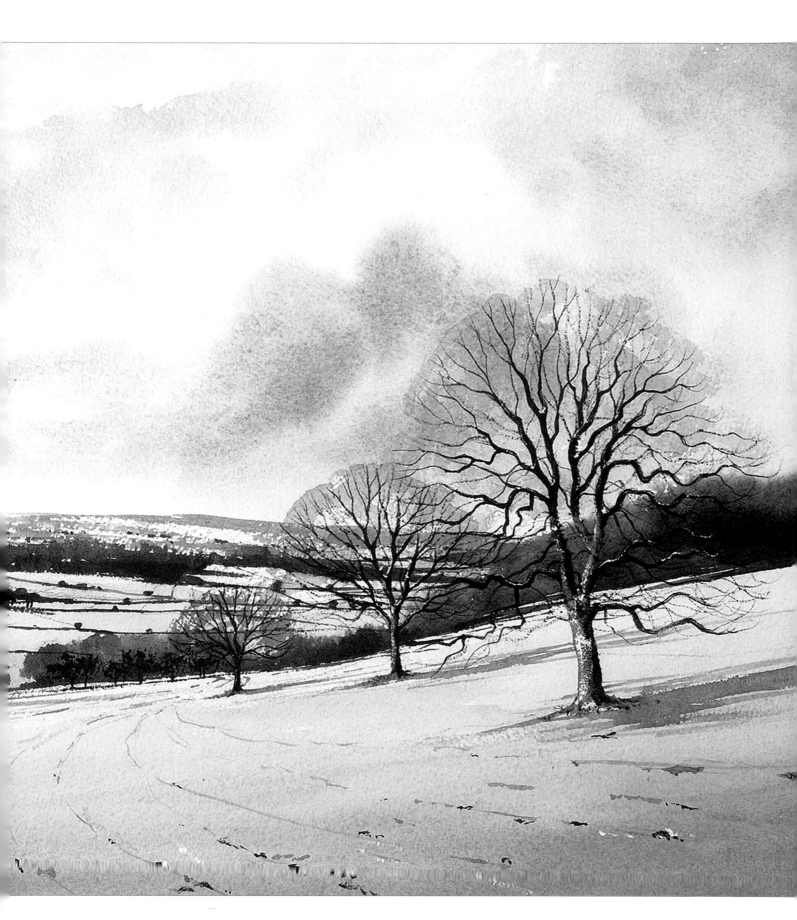

You WILL NEED

Rough paper, 530 x 350mm
(210 x 13¾in)
Soft pencil
Masking fluid
Sponge
Naples yellow, cadmium red,
cobalt blue, cobalt violet,
burnt sienna, raw sienna,
ultramarine blue
Filbert wash brush
Round brushes: no. 4, no. 6,
no. 10, no. 16, liner/writer

1 Draw the scene. Apply masking fluid to preserve a crisp, white edge where the snow meets the skyline, and also half-way up the largest tree and a little on the middle tree.

2 Mix three sky washes: Naples yellow with cadmium red; cobalt blue; then cobalt blue, cobalt violet and burnt sienna to create a grey/purple. Wet the sky area with a sponge, leaving roughly cloud-shaped patches dry. Pick up the Naples yellow and cadmium red mix on a filbert brush and drop it in at the bottom of the sky.

3 Next paint ragged-edged shapes with the cobalt blue wash. Soften any hard edges with clear water.

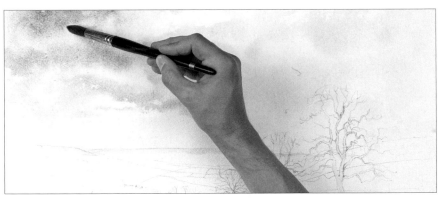

4 Add the purple-grey wash at the top of the sky using the no. 16 round brush. Then paint more of the Naples yellow and cadmium red mix at the top of the sky.

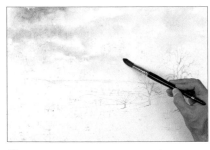

5 Add more of the same pinkish mix near the horizon.

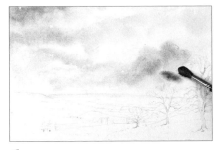

6 Dab in the shape of a dark cloud on the right of the sky with the purple/grey wash.

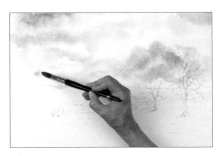

7 Drop the same wash into the wet pinkish paint at the bottom left of the sky.

8 Drop more cobalt blue into the top left of the painting. Allow to dry.

TIP

Do not spend too long working on the sky. If you brush the colours around too much, it can become muddy.

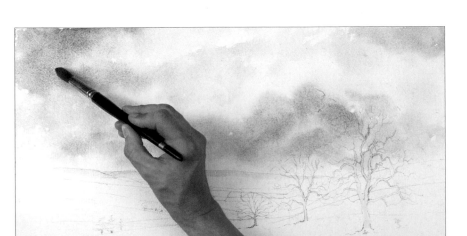

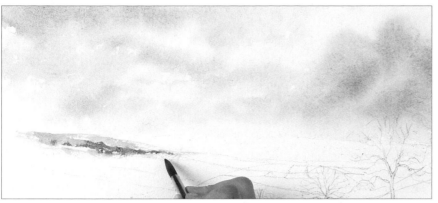

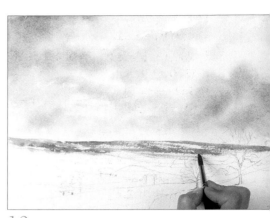

9 Remove the masking fluid from the distant hills. Prepare washes of raw sienna with burnt sienna for the bracken on the hills; cobalt blue and cobalt violet with burnt sienna to make grey; cobalt blue, burnt sienna and cobalt violet for a strong brown. Using the no. 10 brush and the dry brush technique, use the first wash to suggest bracken on the distant hills, then drop in grey while the first colour is wet.

10 Use the grey mix and the dry brush technique to paint texture on the furthest hills. Mix the sky colours, cobalt blue and cobalt violet to paint cloud shadows.

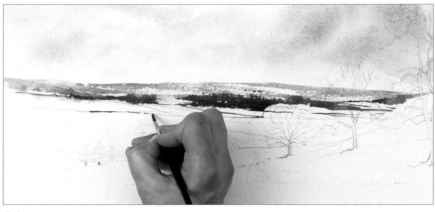

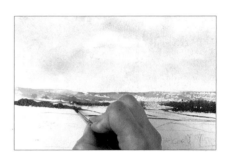

11 Using the strong brown mix, suggest dark patches of forest on the hillsides, and with the point of the no. 4 brush, paint dry stone walls and bushes in the distance.

12 With the same mix, paint shadowed woodland on the left of the painting. Soften the tops with clear water to create a distant, misty look. Pick out shapes in the far distance using the dark grey. Allow to dry.

13 Make two shadow washes: cobalt blue; and a weak, transparent mix of cobalt blue and cobalt violet. Use the no. 16 brush to paint the cooler cobalt blue wash across the middle ground and soften it in with clear water.

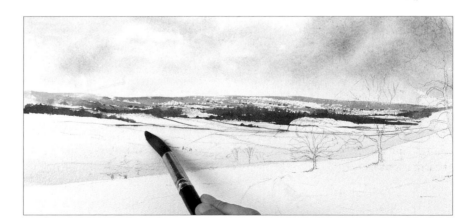

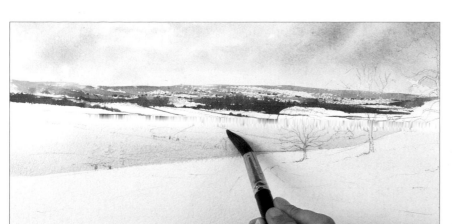

14 Blend in the thin, warmer shadow wash as shown.

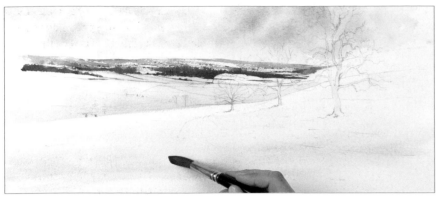

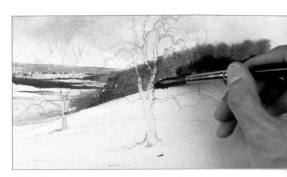

15 Next paint the foreground shadows. Wet the area with clean water and paint the cobalt blue wash across it. Paint in the cobalt blue and cobalt violet mix, making sure your brush strokes follow the contours of the land.

16 Wet the area of the trees on the right, and drop in a mix of cobalt blue, cobalt violet and burnt sienna. Then drop in a darker mix of cobalt blue and burnt sienna at the base of the trees.

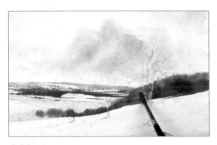

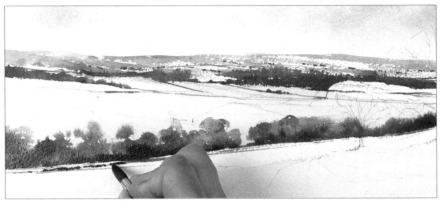

17 Paint soft shapes towards the middle of the painting, then drop in a touch of raw sienna and burnt sienna wet in wet to add warmth.

18 Work on the left-hand side in the same way. Wet it first, then drop in raw sienna and burnt sienna. Then drop in dark shapes using the darker mix. Add a thicker mix of the dark colour at the base and break up the edge against the white as shown.

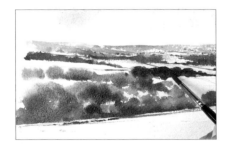

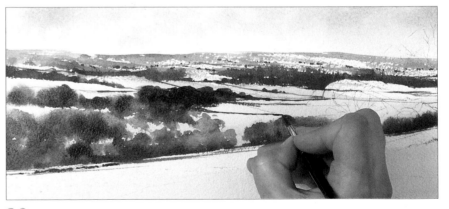

19 Dampen the background on the left and drop in tree shapes using a weak mix of cobalt blue and burnt sienna. Then use a stronger wash of the same colours to paint darker details, and the dense woodland in the middle.

20 Drop a little burnt sienna into the dark areas, wet in wet. Then use the no. 6 brush to suggest dry stone walls across the middle of the area.

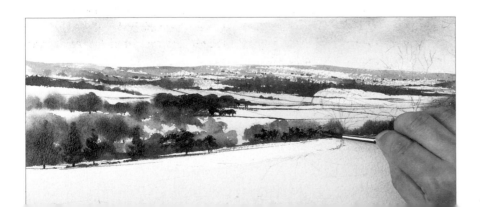

21 Mix a dark brown from ultramarine blue and burnt sienna and suggest fir trees against the soft background. Paint glimpses of trunks and other tree shapes.Use dry brush work to suggest the texture of the trees in the middle.

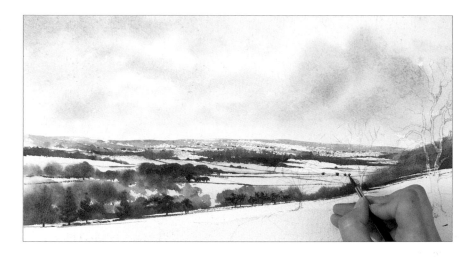

22 Mix cobalt blue, cobalt violet and burnt sienna and suggest distant trees along the dry stone walls with the no. 4 brush.

TIP

When suggesting the shape of the trees, use a very thin wash, leaving gaps through which the sky can be seen.

23 Use the side of the no. 10 brush and a thin mix of raw sienna and burnt sienna to paint in a shape for the biggest tree. Allow it to dry, then add cobalt blue and cobalt violet to the mix to cool it and paint the middle tree in the same way. Allow this to dry, then paint the third tree.

24 Rub off the masking fluid from the trees. Mix a strong, dark brown from burnt sienna and ultramarine blue and use the no. 4 brush to paint the trunk and branches of the smallest tree. Then use the liner/writer brush to paint the finest branches, reaching to the edge of the tree shape you put in earlier.

25 Paint the light on the middle tree using raw sienna and burnt sienna and the no. 4 brush. Then drop in burnt sienna and ultramarine blue to shadow the right-hand side before the first colour has dried. Complete the tree by extending the branches to the edge using the liner/writer brush (see inset picture).

26 Paint the right-hand tree in the same way, starting with raw sienna and burnt sienna. Then drop in the dark shadow mix wet in wet.

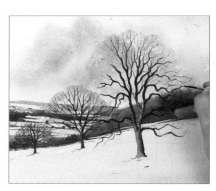

27 Continue developing the branches using the dark brown and the no. 4 brush. Paint in the direction the tree grows, from the ground upwards. Then take the liner/writer brush and follow the branches to the edge of the tree shape. Some should cut across the trunk.

28 Use the liner/writer brush to texture the trunk bark with the dark mixture of burnt sienna and ultramarine.

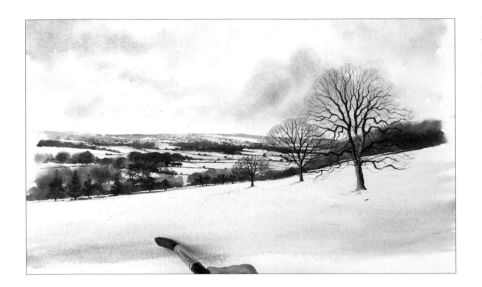

29 Wet the foreground with clean water and a no. 16 brush. Mix a wash from the sky colours cobalt blue and cobalt violet, to create shadows to bring the foreground forwards. Paint shadows in the snow coming from the left.

TIP

Use the angle of your brush strokes to describe the contours of the land.

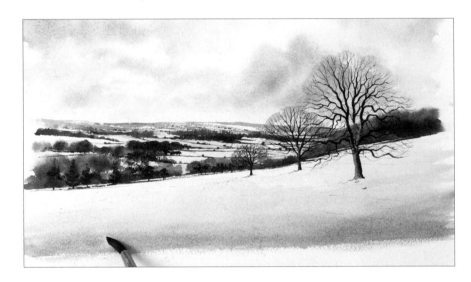

30 Add burnt sienna to the mix and paint it across the extreme foreground to warm the shadows.

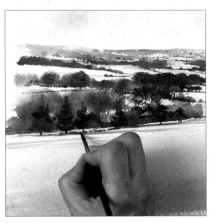

31 Use a no. 6 brush and the mix of cobalt blue and cobalt violet to paint cast shadows coming from the trees on the left.

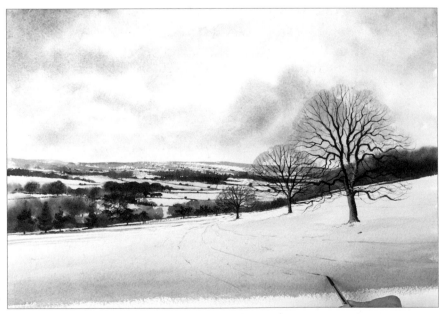

32 When the shadows have dried, use the same mix to suggest tracks through the snow with curved, disjointed lines. These will lead the viewer's eye into the picture. Soften the tracks in places using clean water.

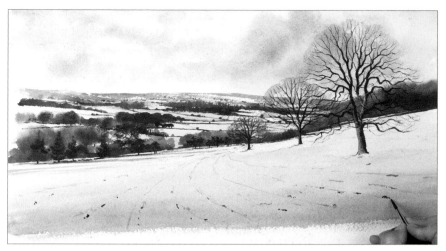

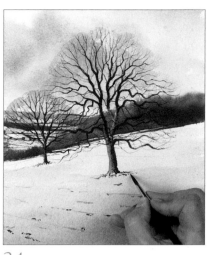

33 Paint dark patches showing through the snow in the foreground using the same brush and a mix of burnt sienna and ultramarine blue. These are also useful to create perspective and lead the viewer in to the scene.

34 Add dark patches around the base of the tree trunks in the same way.

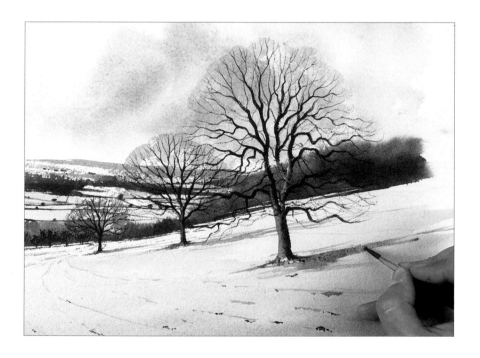

TIP

You can put a little arrow mark in the margin of your painting to remind you of the direction of the light.

35 Paint cobalt blue and cobalt violet shadows from the trees. The light is coming mainly from the left, so although there should be some shadow on the left, long cast shadows should fall to the right of the trees, slanting slightly upwards with the hill.

36 Finally use white gouache to add some details to some tree branches, and add a dusting of snow to the largest tree's trunk.

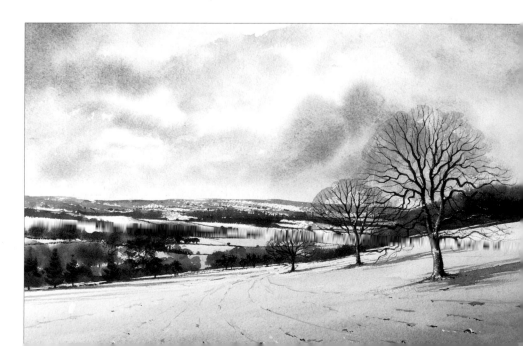

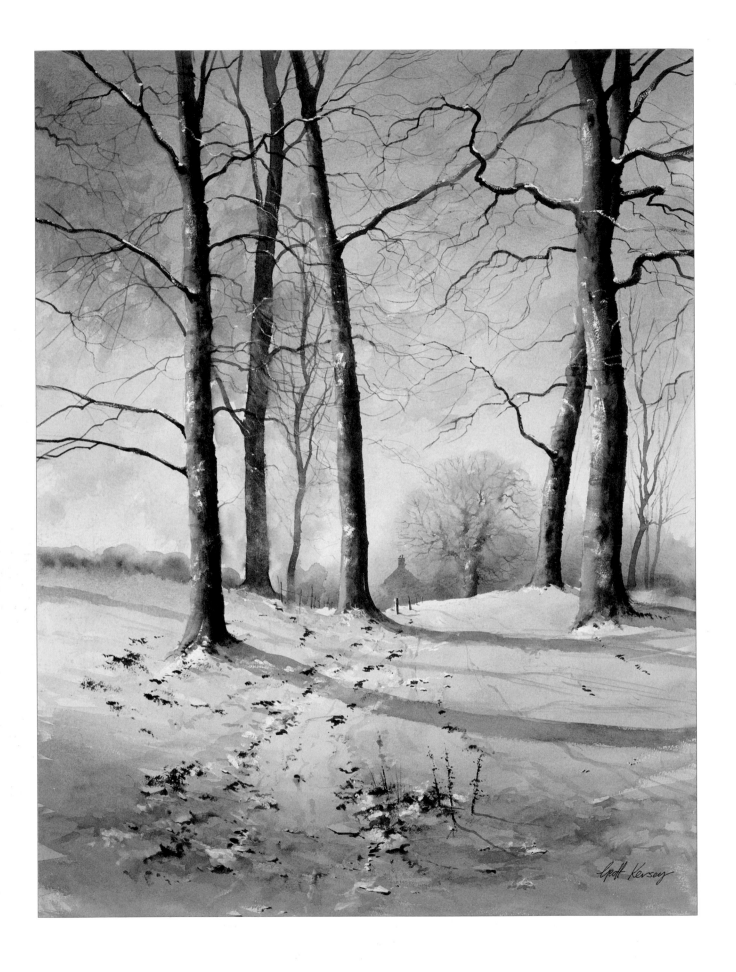

Opposite
Afternoon Light, Calton Lees

68 x 48cm (27 x 19in)

This is another scene in Chatsworth Park, quite near my home in Derbyshire. I have tried to capture the feeling that the whole subject is bathed in a warm, afternoon glow by mixing a rich orange colour from aureolin and burnt sienna for the middle and lower part of the sky, followed by a mixture of cobalt blue and rose madder for the top. Both the blue and orange colours were quite strong mixtures, so that the sky – as well as having a bright glow – gave the impression it was darkening towards early evening. I have carried these sky colours through into the snow, only leaving a small amount of white paper showing. I think the little house in the distance, glimpsed through the trees is quite important as the eye follows the path and settles on this feature. Finally, note how the tree to the right of the house is rendered with soft colours, slightly out of focus, to give it a distant look.

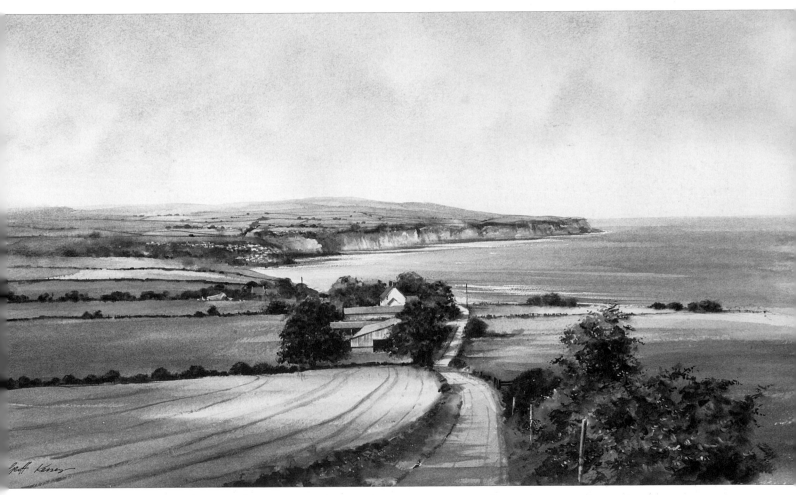

Looking Towards Robin Hood's Bay From Ravenscar

75 x 43cm (29½ x 17in)

In this scene on the Yorkshire coast, I have created a soft, dull sky to give the impression of diffused light, complemented by some bright colours on the land. The land was glazed over with various washes to indicate cloud shadow, which gives the impression that even though it is a dull day, the sun is just breaking through, illuminating areas of the landscape. In the sky I used a pink colour mixed from rose madder and Naples yellow and a soft grey from cobalt blue with rose madder. I used cobalt blue with rose madder for the shadows on the distant hills and the road. For the shadows glazed across the fields I used a darker version of the colour underneath, for instance the large field in the left-hand foreground is a bright green mixed from aureolin and cobalt blue, and the shadow glaze is mixed from the same two colours but with more blue to make it darker.

49

Sky and Water

At the southern end of Derwentwater in the Lake District, there is a marshy area with a long boarded walkway that affords some marvellous views towards the lake and distant hills.

I liked the bright yellow/browns of the reeds and the way the sky was mirrored in the almost still water, the direction of which leads the viewer through the marshes towards the distant hills.

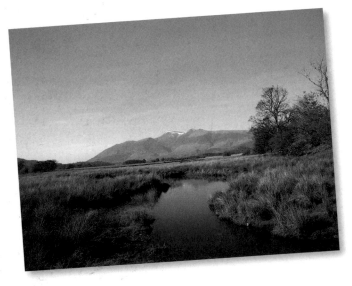

The reference photograph.

The preliminary sketch.

1 Draw the scene. Paint masking fluid on to the tree trunks on the right and where the land meets the bottom of the hill, to preserve the horizontal line.

2 Mix plenty of each sky wash first: ultramarine blue and cobalt blue; a thinner mix of cobalt blue alone; cobalt blue and light red to make a warm grey; and light red on its own. Take a filbert wash brush and wet some areas of the sky, leaving others dry to suggest cloud formations. Drop the ultramarine and cobalt blue mix in to the wet paper.

3 Drop in the paler wash of cobalt blue lower down, brushing over the tops of the hills.

4 Change to the no. 16 brush, pick up the grey mix and paint shadows into the cloud shapes. Soften the shapes with clean water.

5 Drop in some of the light red wash wet in wet to add warmth to the clouds. Soften it in with clear water.

6 Drop in more grey to strengthen the clouds.

7 Add grey streaks in the lower part of the sky. These should give the impression of clouds a long way in the distance, which helps with perspective. Leave the painting to dry.

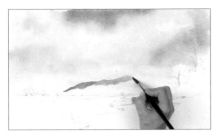

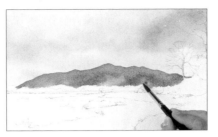

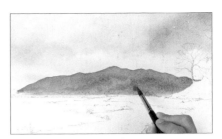

8 Mix a warm grey wash from light red and cobalt blue; an orange wash from raw sienna and light red; and green from aureolin and cobalt blue. Paint the distant hill with the warm grey and a no. 10 brush.

9 Brush in the orange wash wet in wet across the middle, then drop in more grey lower down.

10 Paint more of the orange mix down to the level ground, and drop in touches of the green wash.

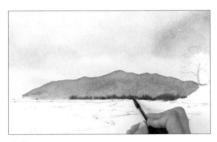

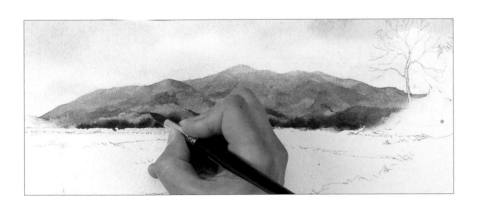

11 While the paint is wet, mix aureolin and ultramarine blue and add burnt sienna to make a rich olive green and touch this in to suggest trees where the hill meets the ground. Drop in a darker mix of burnt sienna and ultramarine blue at the bottom.

12 When the hill area has dried, soften the hard lines at the right and left-hand sides of the hill using clean water. Use the no. 10 brush and clean water to wet the top of the hill, then dab it with a paper tissue, a small area at a time. Take care not to remove too much colour. A soft edge will make the hill appear more distant.

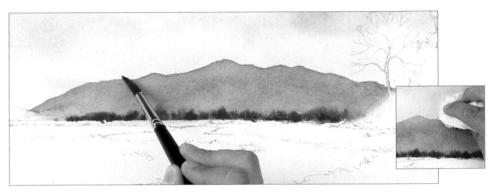

13 Paint shadows on the right of the hill using the no. 10 brush and cobalt blue and light red. Soften the shadows with a damp, clean brush. Continue painting shadows to create form. Use a stronger wash of the same mix to paint in details such as crevices and fissures in the rock.

14 Mix a stronger wash of cobalt blue and light red; and aureolin, cobalt blue and burnt sienna for an olive green. Using the no. 7 brush, paint the shape of the hill on the left with the cobalt blue and light red. The stronger colour will make this hill look nearer than the hill on the right. Add warmth using the orange mixed from raw sienna and light red.

15 Paint trees from the left-hand side using the olive green mix, then drop in undiluted aureolin to create highlights. Brush in more aureolin. Then mix a very dark green from aureolin, ultramarine blue and a little burnt sienna to paint the middle trees. The colour of the trees should gradually get stronger as they get nearer.

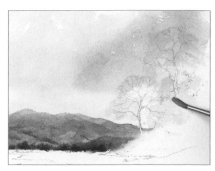

16 Mix the washes for the right-hand side of the painting: a brown from burnt sienna and cobalt blue; a mid-green from aureolin and cobalt blue; a dark green from ultramarine blue, aureolin and burnt sienna; and a beige from Naples yellow and light red. Use the no. 8 brush and beige to paint the shape of the trees, leaving gaps through which the sky will show.

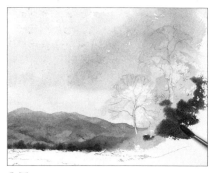

17 Drop in the mid-green wash, then the brown wash.

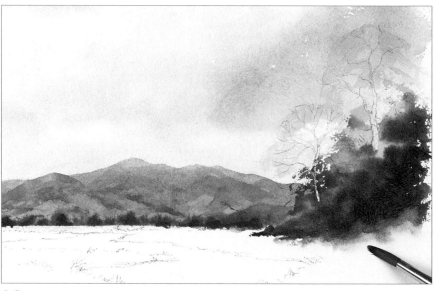

18 Add the dark green wash using the side of the brush, then float the mid-green into the wet colour so that it blends in. Soften with clear water at the bottom.

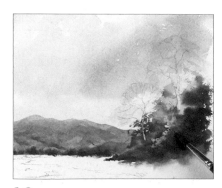

19 Lay the slightly opaque mix of Naples yellow and light red into the dark colours and soften it in with a clean, damp brush.

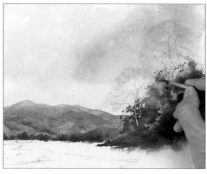

20 Using the no. 4 brush and the dark green, suggest a few leaves.

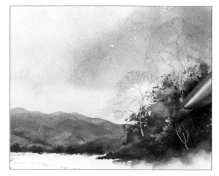

21 Just before the paint dries, as the shine goes off the paper, scratch out lines using a craft knife to suggest branches and twigs.

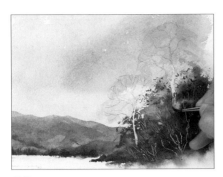

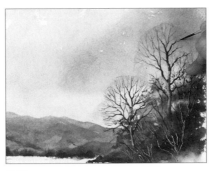

22 Remove the masking fluid. Use clean water to soften the tree trunks into the surrounding undergrowth.

23 Paint the left-hand side of the trunks and branches with Naples yellow and light red, and the right-hand side with ultramarine blue and burnt sienna. Start with a no. 4 brush, then change to a liner/writer as you move out to the edges of the wash. Complete the second tree in the same way.

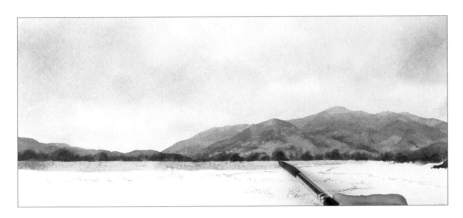

24 Mix washes for the middle ground: Naples yellow and light red; raw sienna and light red; a mid-green from aureolin and cobalt blue; aureolin, ultramarine and burnt sienna for a dark green. First paint on raw sienna and light red for the light catching the marshes, using a no. 10 brush.

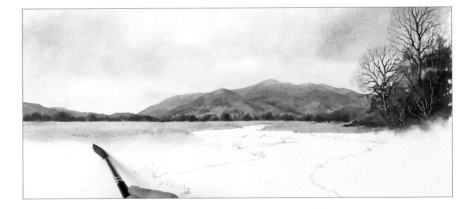

25 Next add Naples yellow and light red with the no. 10 brush. Then add the green wash coming forwards, wet in wet. Soften it using clean water.

26 Paint more of the orange mix around to the bottom right and fade it out using clean water. Paint the dark brown to suggest peat where the marsh meets the water. The brown should spread into the orange wet in wet.

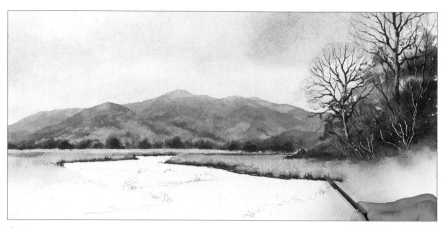

27 Add streaks of the same brown using the point of the brush, to show variations in the colour of the grass. Add more green along the dark peat at the water's edge.

28 Wet the area along the water's edge with clean water. When the shine starts to go, drop in masking fluid. It will make feathery shapes. This can be tricky and is worth practising first on a separate piece of paper. Allow to dry.

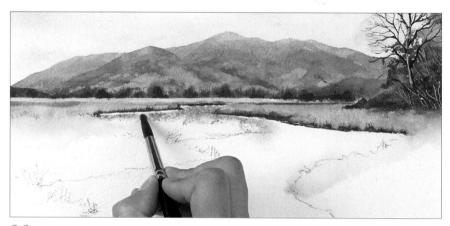

29 Water, especially still water, should not just be blue, but should reflect the sky and the landscape. Mix all the colours you will need to paint the reflections. Wet the paper over the whole water area, leaving a tiny dry line at the very edge, then paint the reflection of the hill using cobalt blue and light red.

30 Drop in raw sienna and light red for the orange of the hill; and green mixed from aureolin and cobalt blue. Then add a weaker wash of the dark brown mix to paint the reflection of the peat at the water's edge.

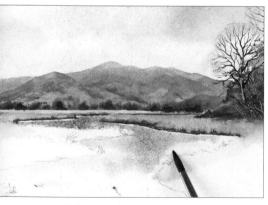

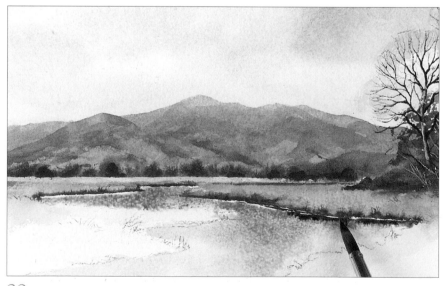

31 Drop in cobalt blue and then light red wet in wet to reflect the sky colours.

32 Paint raw sienna and light red where the grasses are reflected in the water, then add a reflection of the peat colour.

33 Paint the ultramarine blue and cobalt blue mix that appears at the top of the sky at the bottom of the water.

34 Add cobalt blue in the middle of the water, then use the tip of the brush to paint the reflection of the peat under the far bank.

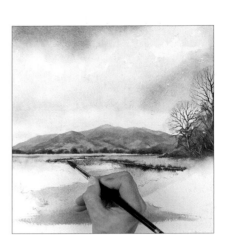

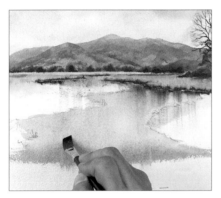

35 Working quickly while the washes are still wet, take a clean, damp 1.5cm (½in) flat brush and stroke it down to suggest vertical reflections.

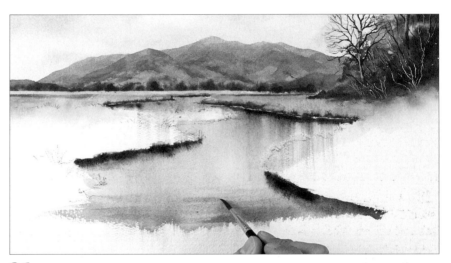

36 Use the no. 10 brush to paint the peat on the left and right banks. Paint raw sienna and light red underneath. Take the no. 6 brush and cobalt blue mixed with ultramarine blue and suggest ripples in the foreground.

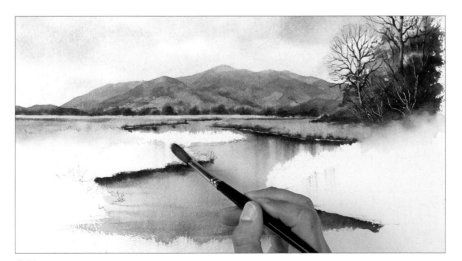

37 Once all this has dried, rub the masking fluid off the banks and clean up any stray marks. Prepare washes: raw sienna and light red; aureolin and cobalt blue; aureolin, ultramarine blue and burnt sienna for a dark green; burnt sienna and ultramarine blue; and Naples yellow and light red.

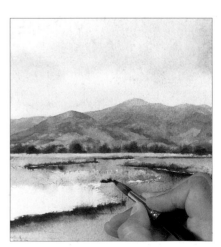

38 Use the no. 10 brush to paint raw sienna and light red on the left-hand bank. Drop in the mid-green mix of aureolin and cobalt blue wet in wet, then the dark peat colour.

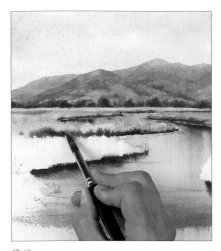

39 Add the dark green mix to the peat at the water's edge.

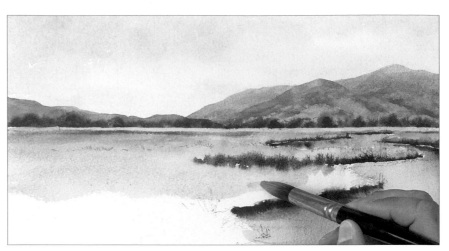

40 Take the no. 16 brush and sweep the Naples yellow and light red wash across the land on the left, then add raw sienna and light red, working down the middle ground.

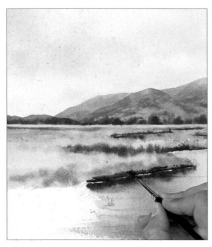

41 Drop in mid-green on the left-hand bank, then add peat above the water line.

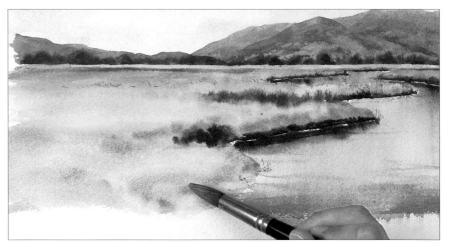

42 Add dark green to accentuate the bend in the water's edge, then paint raw sienna and light red down to the foreground. Drop in mid-green wet in wet.

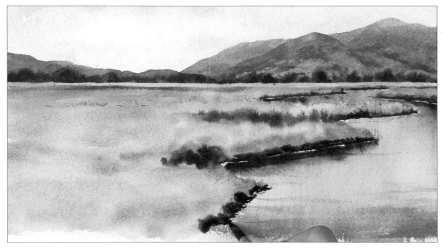

43 Use the same green to accentuate the point at the water's edge, then add the dark peat with the tip of the no. 10 brush.

44 Add more green to suggest grasses. Wet the water area just beyond the left-hand bank and drop in the dark peat colour. Soften it in with clean water to suggest rippled reflections.

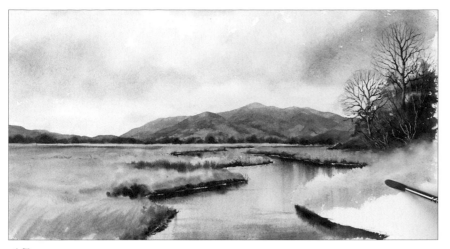

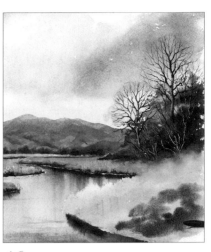

45 Paint the right-hand bank in the same way. Start by applying a wash of light red and Naples yellow, then blend in raw sienna and light red. Add a little mid-green.

46 Paint the same progression of washes wet in wet down to the water's edge, then float in dark green.

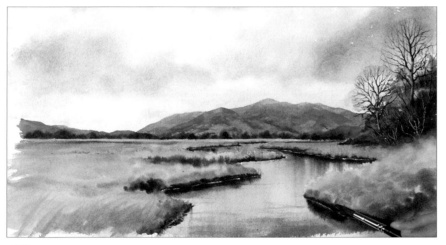

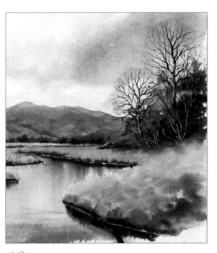

47 Add more raw sienna and light red to soften in the green. Before it dries, paint the rick dark brown for the peat at the water's edge and soften this in with green.

48 Paint the reflection of the dark peat in the water.

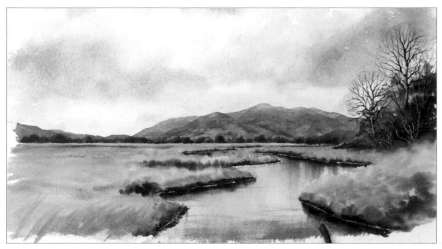

49 Paint the reflections of the other colours from the bank in the water, by wetting the area first, then dropping the colours in.

TIP

Before wetting the water area, make sure you have all your colours mixed and you are ready to go.

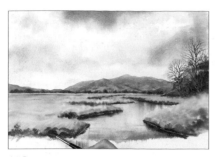

50 Paint the dark green mix in the left-hand side of the foreground, dampening the background to blend it as required. This rich, dark green should help bring the foreground forward.

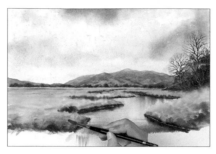

51 Blend in the dark green using the raw sienna and light red mix. Add more green, and allow the painting to dry.

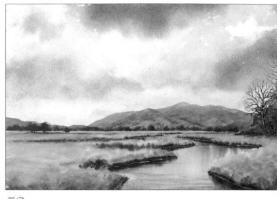

52 After standing back to have a look at the painting, I used dark brown paint and the dry brush technique to paint in some tree shapes and trunks. I then painted some ripples in the water using white gouache on a no. 4 brush. I mixed white gouache with a little raw sienna and painted in some grasses and reeds against darker areas in order to establish the foreground of the painting.

Kippford, Scotland

42.5 x 25.3cm (16¾ x 10in)
In this painting, I liked the way the yellow glow in the sky and the muted greys in the distant hills were reflected in the sea. For the sky glow I used quinacridone gold, cobalt blue with cobalt violet and a grey mixed from cobalt blue, cobalt violet and burnt sienna. When I got to the water area these colours were repeated with horizontal brush-strokes to give the impression of lapping waves.

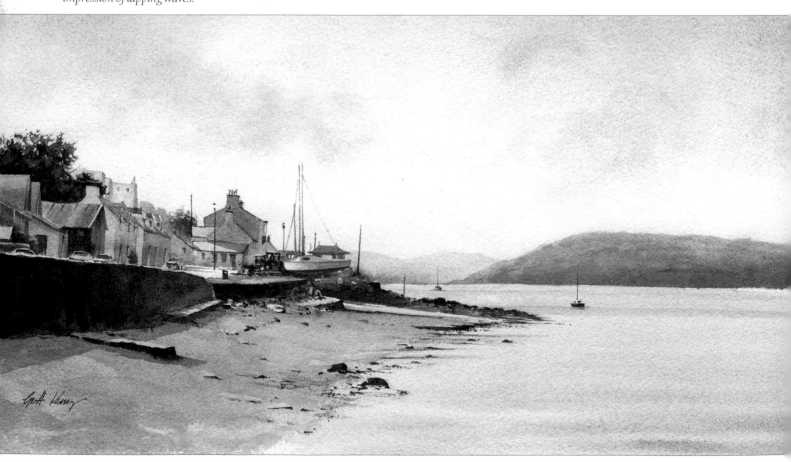

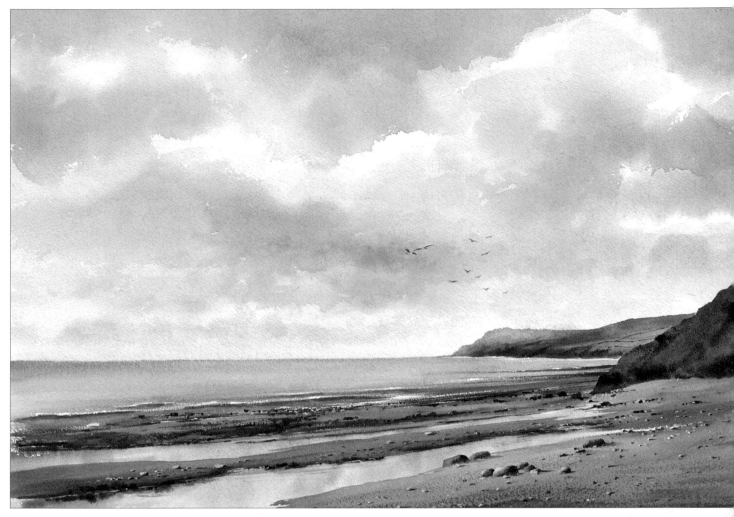

Boggle Hole, Robin Hood's Bay

54 x 36.5cm (21¼ x 14⅜in)

In a scene like this one on the Yorkshire coast, you get the opportunity to suggest the breaking waves of the sea, contrasted with the reflections in the still water of the various rock pools. I coated the sky area with clear water, leaving a few dry edges roughly in the shape of clouds. Then I laid in a wash of cobalt blue followed by a wash of cobalt blue mixed with a touch of rose madder. While the background was still wet I dropped in a hint of Naples yellow with burnt sienna to warm the sky area just above the horizon, and allowed it to dry. For the next stage I added burnt sienna to the cobalt blue and rose madder mix, to create a thin grey glaze. I now indicated the cloud shadows using this grey wash, deliberately leaving some hard edges in some places and softening some others using a damp clean brush. It's this variety of "lost and found" edges and the transparency of the thin glazes that makes this type of sky work. To indicate the sea I used the same blue and grey mixes from the sky, adding just a touch of viridian in the area where the sea meets the shore. When this was dry I indicated the waves with a touch of white gouache. The sky reflections in the still water were indicated in the same way as described in the main demonstration in this chapter.

Stormy Sky

In this painting I wanted it to appear as though sunlight breaking through a gap in the heavy clouds was illuminating the little cluster of buildings on the cliff-top. I really liked the sky in the first reference photograph (below, top) and the way it created a sparkling effect on the sea, but the buildings were silhouetted and looking a little flat. I had in mind for this scene a definite light and dark side to the buildings and I wanted to use some colour to make them appear sunlit, so I used a photograph I had taken a day or two earlier to supply me with this information (see below, bottom). I realise to some this may seem a bit contrived or over-complicated, but it gave me a working method to try and achieve the picture I envisaged at the outset.

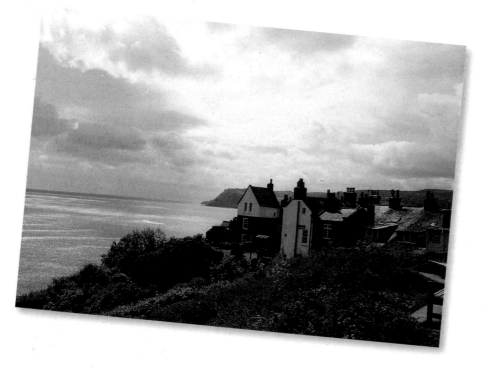

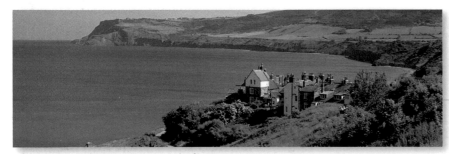

The reference photographs.

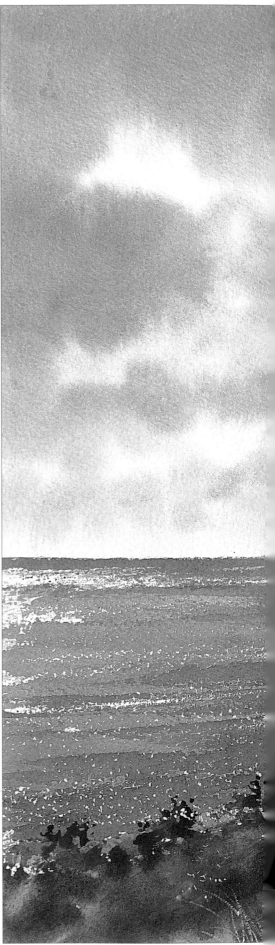

The finished painting.

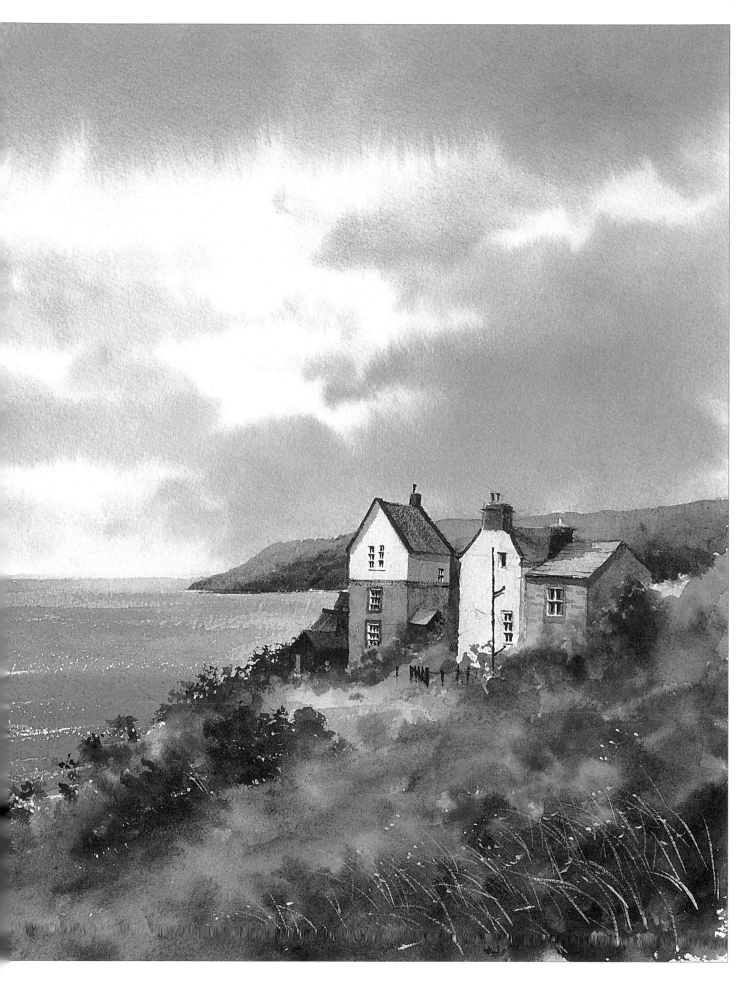

1 Draw the scene, then use a piece of white candle to create wax resist where you want to imply sparkles on the water.

TIP

Do not overdo the wax resist as it is not easy to see what you are going to get when you add paint.

2 Next use masking fluid to mask out the areas you want to keep white: the tall whitewashed buildings that are the focal point of the painting; the rooftops on the left, and part of the horizon.

3 Mix your sky washes before beginning to paint: cadmium red; cadmium red and cobalt blue; neutral tint; sepia; and cobalt blue. Sponge the sky area with clean water, going over the tops of the buildings and the cliff. Take a no. 16 brush and paint a very thin wash of cadmium red to tint the lower sky.

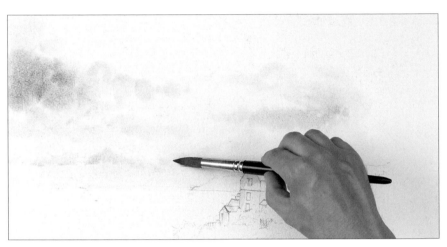

4 Pick up the cadmium red and cobalt blue mix and paint cloud shapes wet in wet on the left and right of the sky with the side of the brush. Then use the point of the brush to paint smaller clouds lower down.

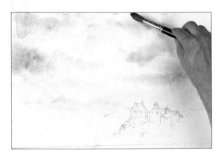

5 Drop in some cobalt blue at the top of the sky, leaving some white paper showing.

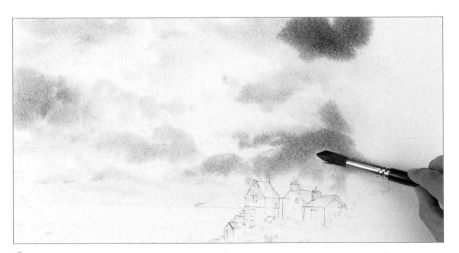

6 Paint dark clouds using neutral tint, to create a dramatic, stormy look to the sky, especially behind the houses, where it will contrast with the brightness of the buildings.

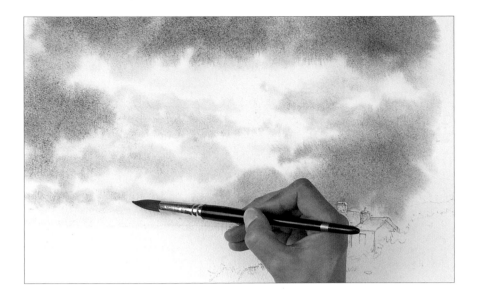

7 Drop in a brush full of sepia from the top of the painting, allowing the colours to mix on the paper. Add more sepia behind the houses and still more at the top of the sky. Then paint small cloud shapes in the pink near the horizon with a weaker mix of sepia.

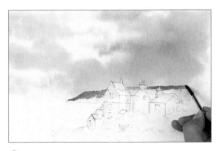

8 Rub the masking fluid from the horizon, and prepare the paint mixes for the next section of the painting: cobalt blue and cadmium red; lemon yellow and raw sienna; neutral tint; and burnt sienna and cobalt blue. Take a no. 8 brush and paint the cliff with the cobalt blue and cadmium red mix.

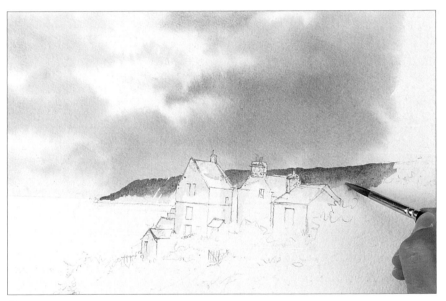

9 While the paint is wet, drop in the lemon yellow and raw sienna mix lower down, allowing the colours to blend on the paper.

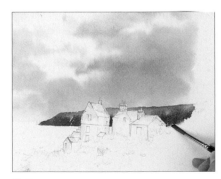

10 Bring the edge of the cliff to a fine point using a no. 4 brush and the burnt sienna and cobalt blue mix. Soften the hard edge at the right of the cliff using clean water and allow the painting to dry.

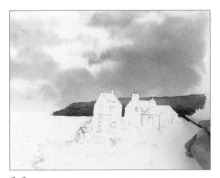

11 Remove the masking fluid from the larger buildings and tidy up the edges using the colours from the background.

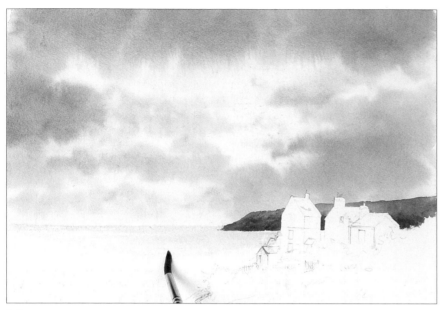

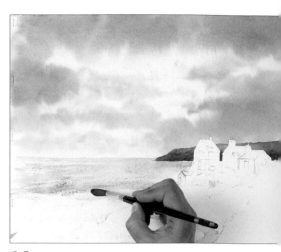

13 Next brush in the cobalt blue and cadmium red mix, painting over the wax resist to create a sparkling effect.

12 Prepare the washes for the sea, which should contain the same colours as the sky: cadmium red; neutral tint; cobalt blue and cadmium red; and sepia. Use the no. 10 brush and paint a hint of cadmium red with water up to the horizon. Brush water in to soften it.

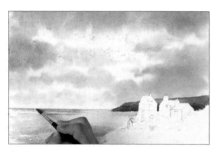

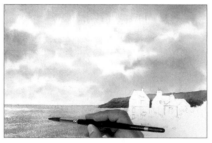

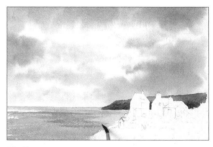

14 Paint with neutral tint at the lower edge of the water area, and add a little on the horizon.

15 Next add streaks of sepia to reflect the dark clouds, making the colour darker near the foreground. Allow to dry.

16 Working wet on dry, develop the sea, adding streaks of cobalt blue and cadmium red.

17 Add streaks of neutral tint and then a touch of sepia at the lower edge of the water area.

18 Paint a little neutral tint on the horizon, suggesting a dark cloud shadow on the sea.

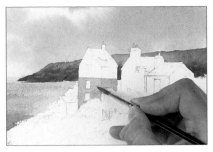

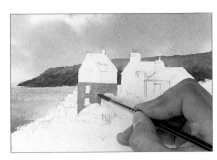

19 Brush the horizon with clean water and dab it with a paper tissue to fade out the hard line. Then use the liner/writer brush and white gouache to suggest waves in the far distance.

20 Use the no. 6 brush and a mix of raw sienna and a little burnt sienna to paint the stone colour on the lower part of the house on the left.

21 Drop in sepia wet in wet.

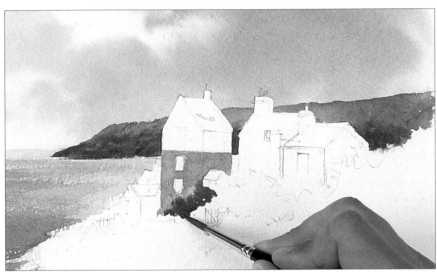

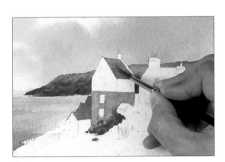

23 Mix a red from aureolin and burnt sienna and paint the roofs to the left of the big house, and the main roof.

22 While it is still wet, touch in a little lemon yellow around the bottom of the house, then mix aureolin and neutral tint to make a dark green, and drop this in to the wet lemon yellow.

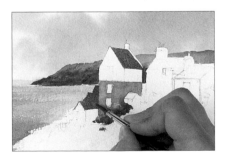

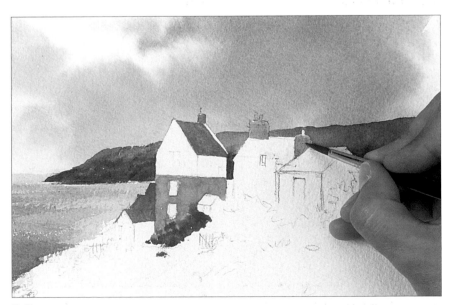

24 Tone down the brightness of the roofs by dropping in a mix of cobalt blue and cadmium red wet in wet. Leave the painting to dry.

25 Paint all the chimneys with the same raw sienna and burnt sienna mix used on the walls.

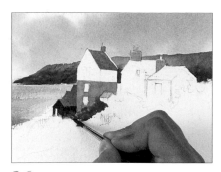

26 Use a mix of neutral tint and burnt sienna to paint the dark building on the left. Before it dries, drop in lemon yellow around the bottom and let it seep into the darker colour, suggesting bushes in front of the house.

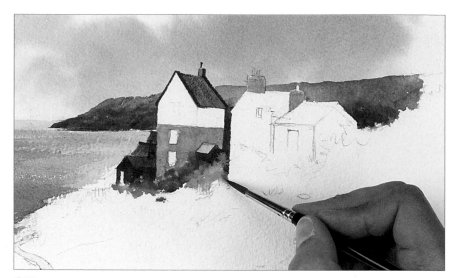

27 Shadow the roofs facing away from the light with cobalt blue and cadmium red. Use burnt sienna and neutral tint with a no. 6 brush to paint the roof ridges. Use dry brush work and the same colour to paint the dark shades of the shed and between the buildings. Add more lemon yellow to the bushes.

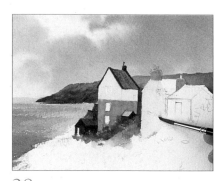

28 The white of the paper is too stark, so apply a faint tint of cobalt blue to the houses. Allow it to dry.

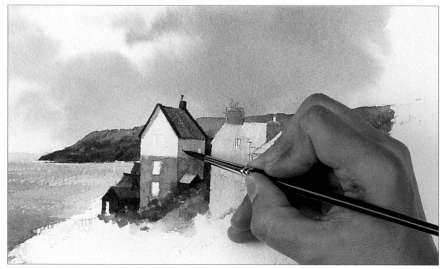

29 Use cobalt blue and cadmium red to shadow the right-hand side. Glaze over the whole side of the building and under the eaves.

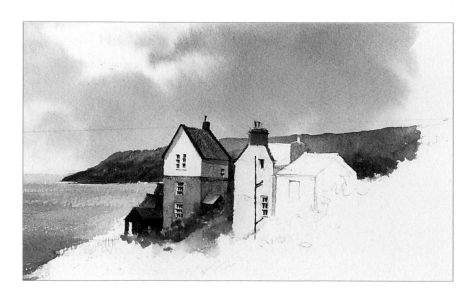

TIP

Make sure the brush you use for detail has a good, fine point.

30 Paint a line where the whitewash joins the stone. Use the same dark mix and a no. 4 brush to paint architectural details and windows.

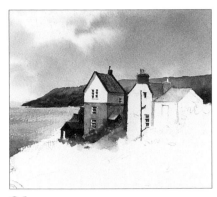

31 Paint the second roof with aureolin and burnt sienna, then drop in cobalt blue and cadmium red wet in wet. Dab off some of the colour with a paper tissue to create texture.

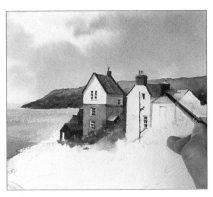

32 Darken the chimney of the third building with neutral tint and burnt sienna. Then paint the shadow on the roof, the shadow side of the chimney and the cast shadow from the chimney using the cobalt blue and cadmium red mix.

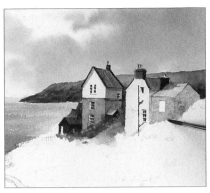

33 Paint the walls of the third building using the no. 6 brush with raw sienna and burnt sienna, then drop in the cobalt blue and cadmium red shadow colour wet in wet.

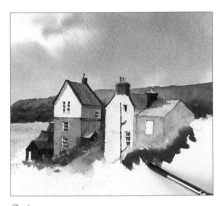

34 Paint the bushes round the bottom of the third building using lemon yellow, then use the no. 8 brush to drop in a dark green mixed from neutral tint, aureolin and burnt sienna to suggest foliage.

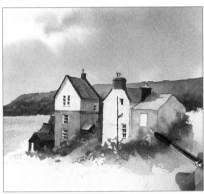

35 Develop the foliage around the front of the middle house using dry brush work. Then drop in a little burnt sienna and lemon yellow and allow the painting to dry.

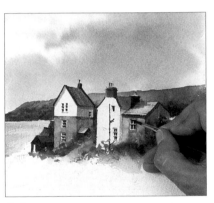

36 Paint shadow on the third building using the cobalt blue and cadmium red mix. Then take the no. 4 brush and paint the window using a strong mix of the same colour.

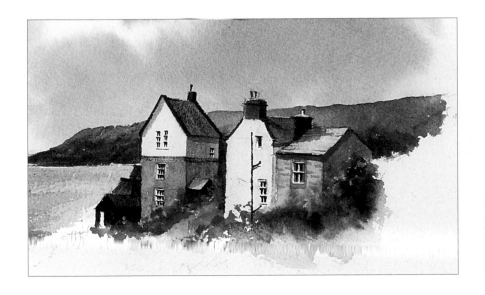

TIP

Burnt sienna always looks brighter if you add a touch of yellow.

37 Indicate stones on the building on the right using raw sienna and burnt sienna. Using the no. 4 brush, paint a shadow cast down the roof from the middle chimney.

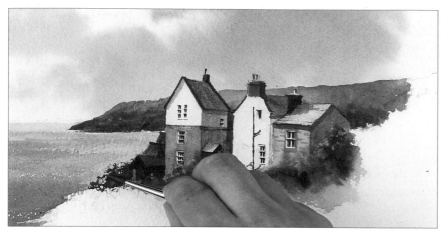

38 Paint the door of the shed in burnt sienna and cobalt blue. Next mix the colours for the hillside: light green mixed from aureolin and a touch of cobalt blue; raw sienna and burnt sienna; lemon yellow; lemon yellow and raw sienna; and a dark olive green from aureolin and neutral tint with a hint of burnt sienna. Take the no. 4 brush and use the dark olive green and dry brush work to paint bushes to the left of the buildings.

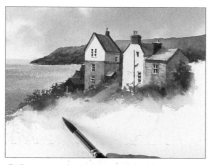

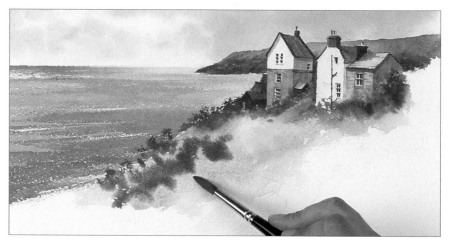

39 Wet the area of the hillside in front of the buildings to help the colours flow. Drop in the light green and then some of the dark olive green, wet in wet. Drop in lemon yellow and raw sienna to suggest the bright colour where light catches the grasses.

40 Float in raw sienna and allow the colours to merge. Add clean water and drop in light green. Drop in dark green at the edge of the sea and over the lighter green, letting the colours blend wet in wet.

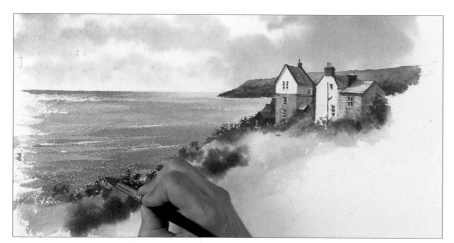

41 Paint raw sienna and burnt sienna on the left-hand edge of the hillside. Drop in the darker green, then add more neutral tint to the dark olive green mix and drop it in at the water's edge.

42 Drop in lemon yellow to merge with the green.

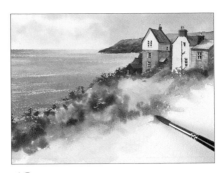

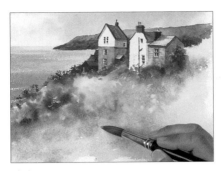

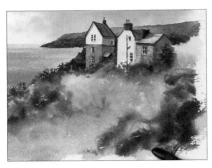

43 Re-wet the foreground so that the colours continue to merge. Drop in raw sienna and burnt sienna and add a little cadmium red.

44 Take the no. 16 brush and paint the aureolin and cobalt blue mix up to the right and the foreground of the painting. Drop in burnt sienna, then lemon yellow.

45 Mix aureolin, neutral tint and burnt sienna to make a very dark green and paint it in from the bottom right.

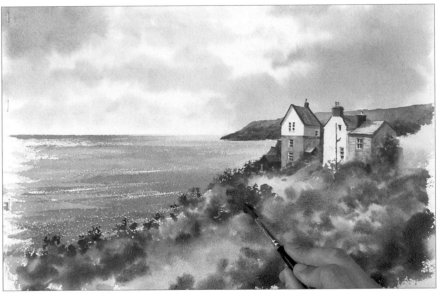

47 Drop burnt sienna into the foreground to add warmth, and add more dark green at the top right. Allow the painting to dry.

46 Add more dark green, especially around the lighter area of the lawn in front of the buildings.

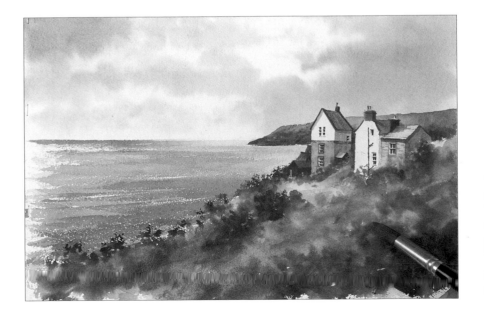

TIP

A few touches of extra detail in the foreground can help bring it forward.

48 Paint the edges of the windows using netural tint and raw sienna. Then pick up the shadow colour, cadmium red and cobalt blue and glaze cloud shadows over the foliage. This will help to unify the painting by echoing the sky colours and the shadows on the buildings.

49 Paint the garden gate and fence posts with neutral tint and burnt sienna using a no. 4 brush. Mix white gouache with aureolin and use a liner/writer brush to suggest highlights, weeds and flowers. Paint grasses with white gouache mixed with a little lemon yellow and cobalt blue.

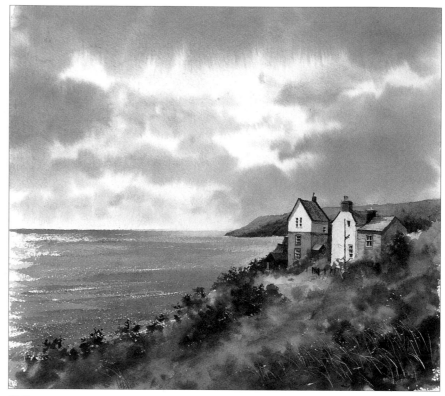

50 Having stepped back to look at the painting, I decided to add a few flower heads in the foreground using white gouache and lemon yellow. I also faded out the hill behind the house with clean water and a paper tissue.

Woodbridge Tidal Mill, Suffolk

45.7 x 30.5cm (18 x 12in)

Here I have painted weatherboarded buildings with brightly lit, orange rooftops under a dramatic cloudy sky. I painted the sky by mixing four separate washes: Naples yellow, cobalt blue, neutral tint and sepia. Then it was simply a case of wetting the top three-quarters of the paper with clean water and laying these colours in, concentrating the sepia at the top so the sky is darker there and gradually lightening towards the horizon.

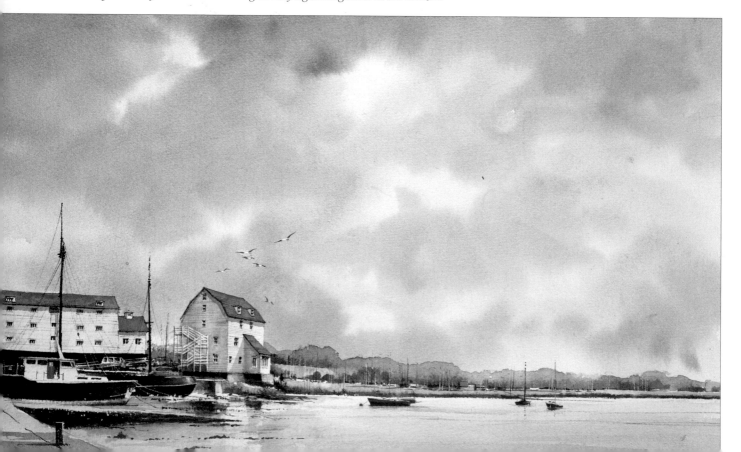

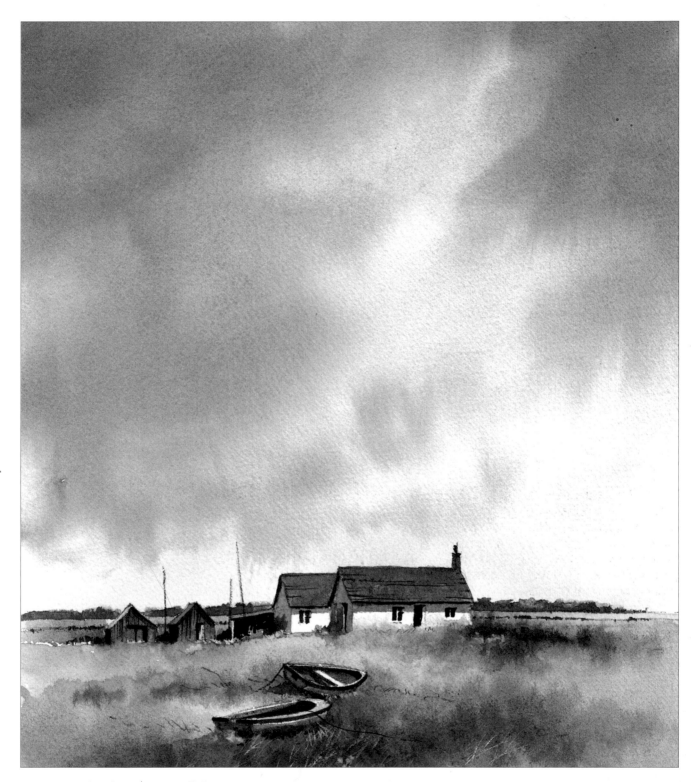

Cottages, Shingle Street, Suffolk

23 x 31cm (9 x 12¼in)

*This couple of whitewashed cottages with old weathered huts on the Suffolk coast gave me an
excellent opportunity to contrast clean white paper with an atmospheric, heavy sky. I used a thin
wash of Naples yellow to take the whiteness off the paper in the lower part of the sky,
immediately followed by a thin wash of cobalt blue in the top two-thirds of the sky, then a much
stronger wash of Payne's grey, also in the middle and top of the sky. Concentrate the heavier
wash at the top and do not cover all the sky area with colour, as the odd glimpse of white and
Naples yellow looks more convincing. I propped the drawing board up at a slight angle to
encourage a running down effect to suggest distant rain, and then left the painting to dry.*

Light and Atmosphere

In this chapter I want us to consider the sky mainly as a source of light, and as a backdrop to the painting. In a painting like the one on the right, depicting sky detail and cloud formations is not as important as seeing the sky colours as a continuous theme throughout the whole scene. It is a good opportunity to practise using a bit of imagination – just think of a set of colours, mix them and lay in some washes, then use this to suggest a painting, rather than starting off with a specific place in mind.

This view from the shore of Lake Garda is quite uncomplicated, relying on a limited palette of colours and simple shapes. Often if you add too much detail, it detracts from the main theme of light and atmosphere and you can lose the very essence of the subject that attracted you in the first place.

The reference photograph.

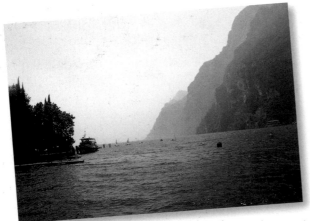

The preliminary sketch.

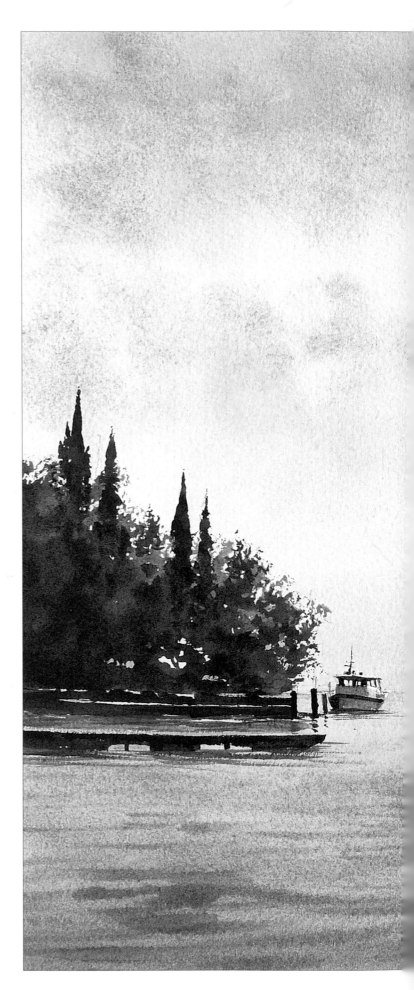

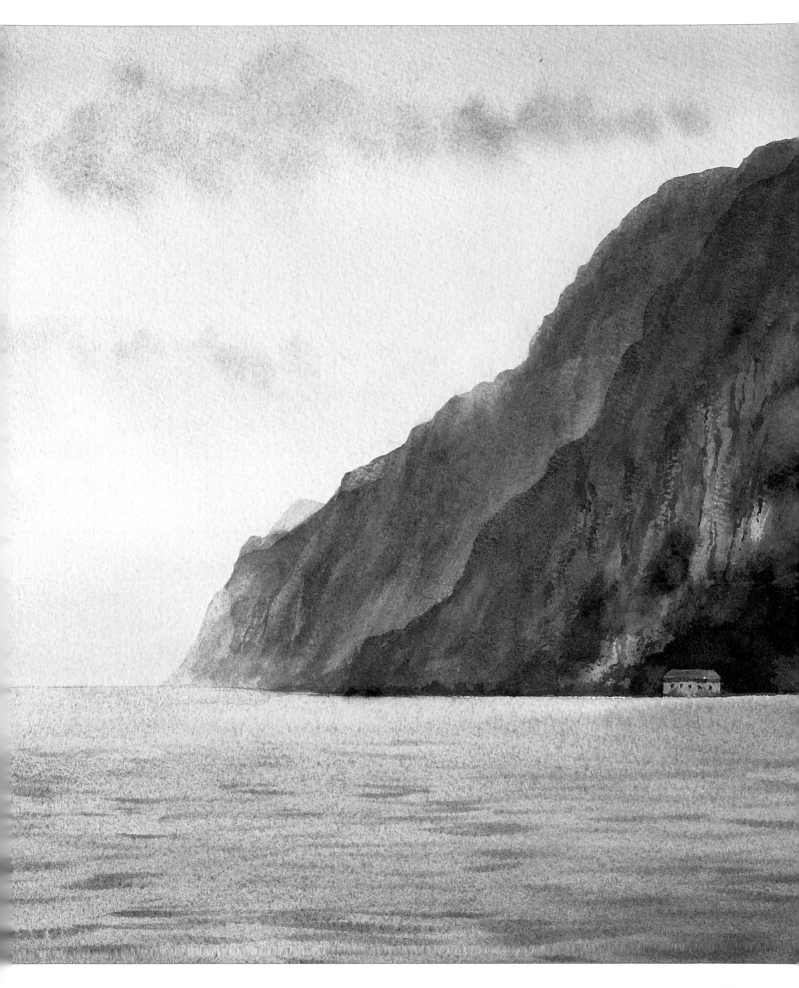

1 Draw the scene. Paint masking fluid where the lake meets the sky and on the boat, jetties and building.

TIP

Keep the sky washes light to achieve a bright glow.

2 Make two very thin washes, one of quinacridone gold and one of burnt sienna. Then mix washes of cerulean blue with a touch of cobalt blue; and cerulean blue with cobalt violet. Sponge over the whole area above the horizon with clean water and use a 2.5cm (1in) flat brush to lay in the quinacridone gold wash from the horizon upwards.

3 Half-way up the sky, blend in the burnt sienna wash. Then paint the cerulean blue and cobalt violet wash from the top, wet in wet.

4 Change to the no. 16 round brush, pick up the cerulean blue and cobalt violet mix and drop in cloud shapes wet in wet with the side of the brush.

5 Drop in burnt sienna to add warmth to the clouds.

6 Drop in more cerulean blue and cobalt violet clouds. As the colours mix and separate on the paper, new colours will form.

7 Add burnt sienna near the horizon. You can tilt the board towards you to let the colours run downhill. Allow the painting to dry.

8 Mix two washes for the mountains: cerulean blue and cobalt violet; a warm grey from cobalt blue, cobalt violet and burnt sienna; and cobalt violet, burnt sienna and cerulean blue. Use a no. 10 round brush to paint the distant part of the mountain in the first colour. The brush strokes should follow the slope of the mountain.

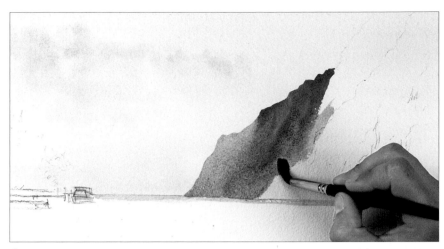

9 Paint the slightly nearer part of the mountain in the stronger warm grey. Add cobalt violet, burnt sienna and cerulean blue wet in wet for the lighter colour lower down. Your brush strokes should always follow the slope of the mountain.

10 Continue with cobalt blue, cobalt violet and burnt sienna to the top of the mountain, and soften the edges with a clean, damp brush.

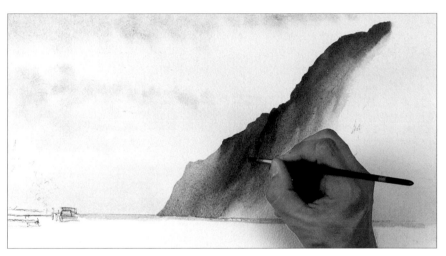

11 Take the no. 6 round brush and use the same mix to pick out crevices in the rocks, still working wet in wet for a soft effect.

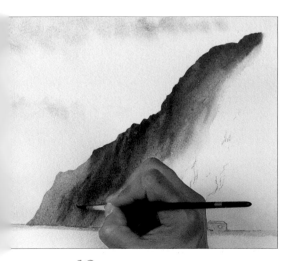

12 Paint more crevices in the more distant part of the rocks, and allow the painting to dry.

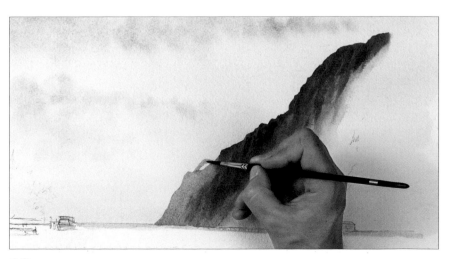

13 Use a no. 6 brush and a thin mix of cerulean blue and cobalt violet to paint in the most distant mountain, and let it dry.

14 Use cobalt blue, cobalt violet and burnt sienna to define the nearer mountain, emphasising that it is in front of the new far-distant peak.

15 Define the distant mountain a little more and allow the painting to dry.

16 Soften the edge of the main mountain using clean water, then blot it with paper tissue.

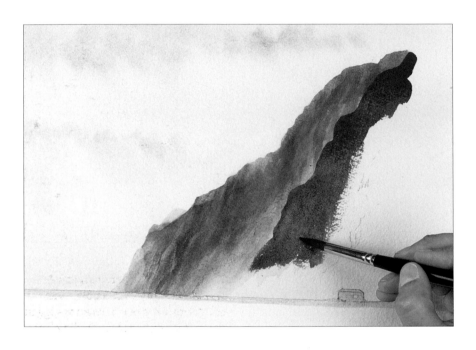

17 Mix the washes for the nearer hillside: cobalt blue, cobalt violet with more burnt sienna; raw sienna and cobalt violet; quinacridone gold with cobalt blue to create a mid-green; quinacridone gold with ultramarine blue to make a dark green; and a pink colour for rocks made from quinacridone gold with cobalt violet. Take the no. 16 brush and the warmer grey and paint in the shape of the nearer mountainside.

Tip

Use a large brush to paint a large area. It will cover the paper more quickly and create a feeling of spontaneity.

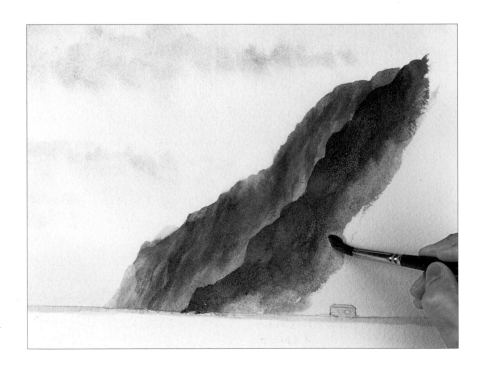

18 Paint in the lighter raw sienna and cobalt violet wash wet in wet.

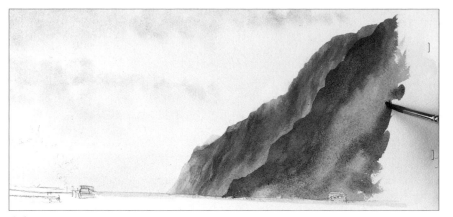

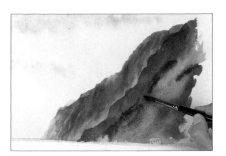

20 MIx cobalt blue and burnt sienna and paint the dark shapes in the mountainside.

19 Add the green mix of quinacridone gold and cobalt blue. Working wet in wet, drop in the darker green mix of quinacridone gold and ultramarine blue.

21 Add burnt sienna to the dark green mix and paint the rich darks behind the building. Leave lighter patches. Use a paper tissue to lift out colour, suggesting rocks catching the light.

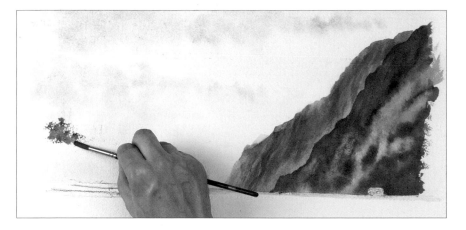

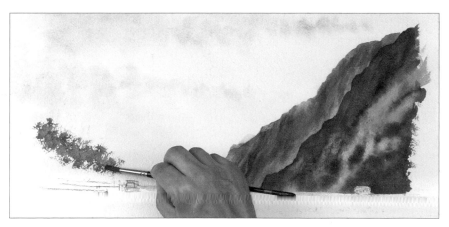

22 Use the no. 8 brush on its side with a warm grey mix of cobalt blue, cobalt violet and burnt sienna to suggest the broken edge of foliage on the left of the painting.

23 Float in the lighter green, mixed from quinacridone gold and cobalt blue, wet in wet.

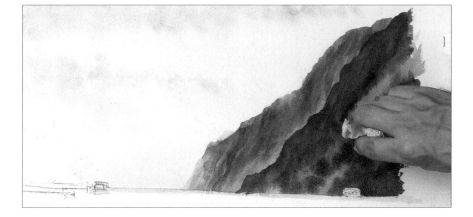

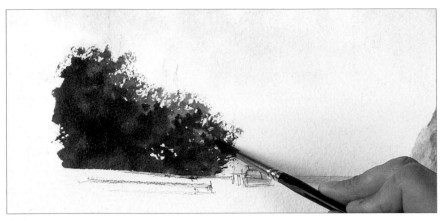

24 Add the rich, dark green mixed with quinacridone gold and ultramarine, leaving gaps to suggest light showing through the foliage. Paint more solid dark green down to the jetty.

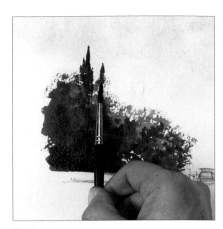

25 Use the shape of the no. 6 brush on its side to print the shape of fir trees emerging from behind the foliage.

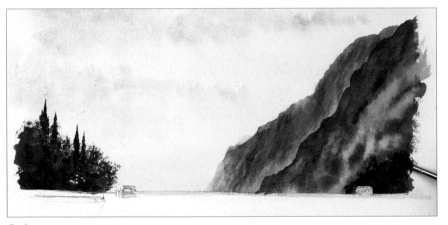

26 Develop the right-hand side of the painting, working in more dark green with the side of the no. 10 brush, then allow to dry.

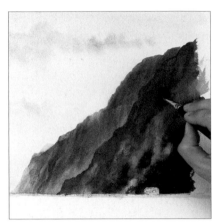

27 Take the cobalt violet, cobalt blue and burnt sienna and the 1.3cm (½in) flat brush and sweep a glaze over the crevice between hills to soften it. Add water and blend the glaze in to the whole area.

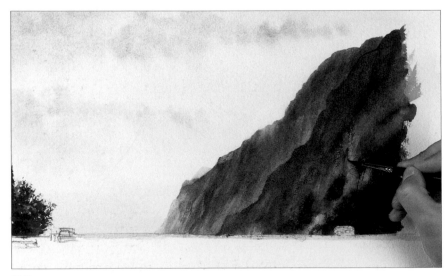

28 Use a thicker mix of the same grey and the no. 6 brush to add details such as crevices in the rocks. Allow the painting to dry.

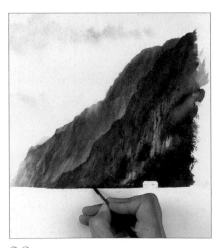

29 Rub off all the masking fluid apart from that on the boat. Neaten the edges of the house and the water's edge using dark green.

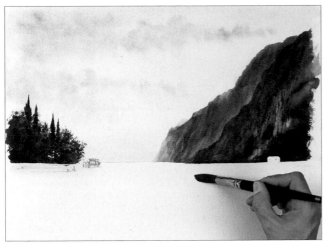

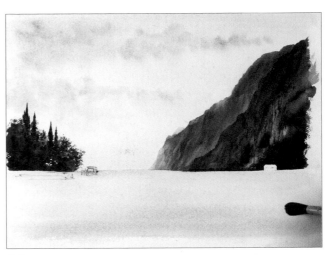

30 Mix colours for the water: very watery quinacridone gold; burnt sienna; cerulean blue; cerulean blue and cobalt violet; and quinacridone gold and cobalt blue. Wet the water area with a flat brush and clean water. Take the no. 16 brush and paint the thin quinacridone gold wash from the top down.

31 Paint the burnt sienna wash near the top, then blend in the cerulean blue wash lower down, always keeping your brush strokes horizontal.

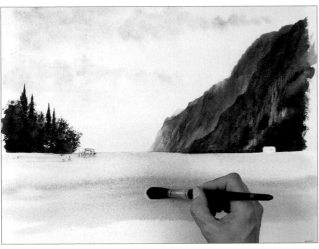

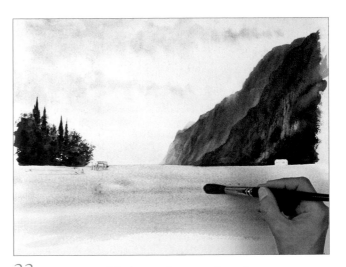

32 Add cerulean blue at the horizon, and then cobalt blue and cobalt violet in the middle.

33 Paint more of the burnt sienna wash as shown.

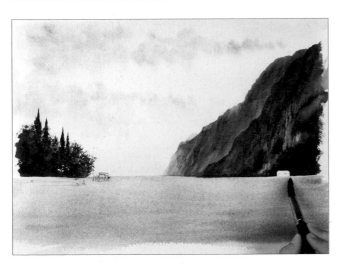

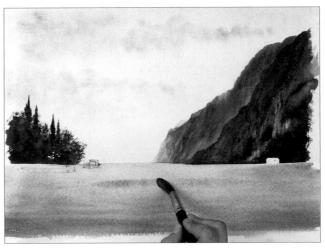

34 Darken the edges at each side with cerulean blue and cobalt violet. Paint with green mixed from quinacridone gold and cobalt blue near the horizon.

35 Add more cobalt blue to the green mix and paint it into the left-hand side. Paint streaks of cobalt violet across the middle of the water and allow the painting to dry.

36 Use a no. 6 brush to paint grey ripples across the foreground with the cobalt blue, cobalt violet and burnt sienna mix.

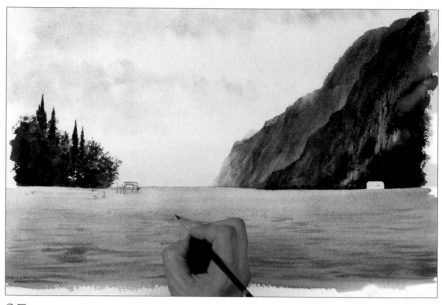

37 Paint bluey-green ripples with the tip of the brush and the quinacridone gold and cobalt blue mix. Return to the warm grey mix and change to the no. 4 brush to paint smaller ripples in the middle of the water, helping to create perspective.

TIP

Do not overdo the ripples. Keep stopping and asking yourself if you have done enough.

38 Soften the horizon using clean water and then blot it with a paper tissue.

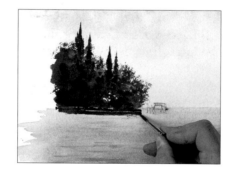

39 Use the dark green mix and a no. 10 brush to bring the green of the trees down into the water. Leave a tiny gap to suggest light on the water's edge. Then paint the dark under the jetty using a strong mix of warm grey.

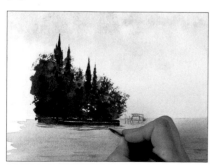

40 Paint ripples using the bluey-green mix so that the dark of the jetty appears to be reflected in the water.

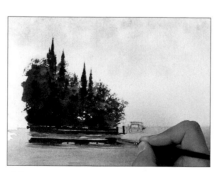

41 Use burnt sienna and ultramarine to paint a post at the end of the jetty. Paint the second jetty in the same way as the first and paint bluey-green ripples between the two.

42 Mix white gouache with a little quinacridone gold and use a no. 4 brush to re-emphasise the top edge of the second jetty, and to suggest light coming through gaps in the foliage.

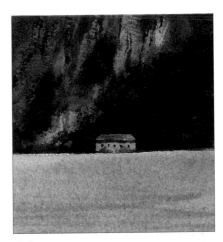

43 Paint the roof of the house on the right with a mix of burnt sienna and raw sienna and a no. 4 brush. Then mix raw sienna with some of the grey mix and paint the walls. Drop in dark green while the wall is damp to suggest bushes at the water's edge.

44 Paint the shadow under the eaves using the grey mix of cobalt blue, cobalt violet and burnt sienna. Indicate windows and add a touch of green to the roof to calm down the red.

45 Rub the masking fluid off the boat. Mix a dark brown from burnt sienna and cobalt blue and paint the dark bands as shown.

46 Soften this dark colour at the bottom into the green of the water with the point of a no. 4 brush and clean water. Then paint grey along the boat's side.

47 Paint more grey at the front of the boat.

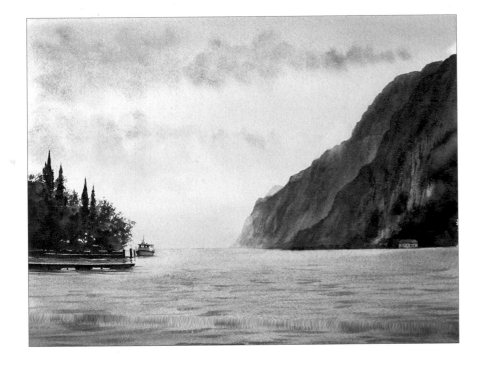

TIP

When softening a hard edge with clean water, make sure the brush is damp rather than wet.

48 Use the dark brown mix to paint the details at the top of the boat, and add an aerial. Finally, paint a mooring post by the jetty.

83

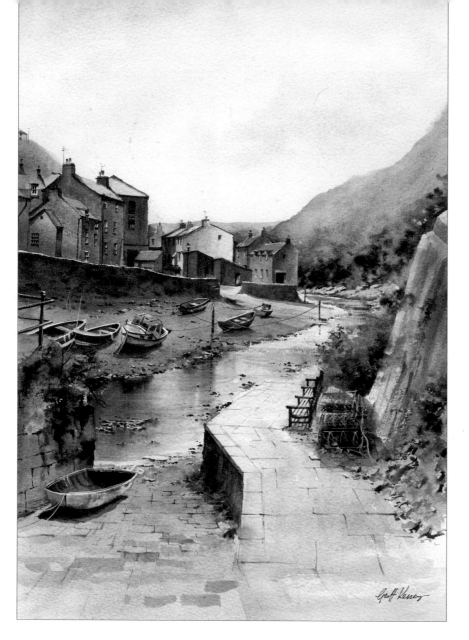

Staithes, Yorkshire

25 x 38cm (10 x 15in)
This little fishing village on the Yorkshire coast has a paintable view round every corner. I prefer to see the tide out, as it leaves the boats leaning at interesting angles with the criss-cross of ropes and assortment of posts. I painted the sky by dropping in three washes of burnt sienna, quinacridone gold and cerulean blue, allowing them to mix and merge on the paper. The distant hills were painted in using a wash of cerulean blue with rose madder, gradually introducing a hint of aureolin followed by a dark green made from viridian, ultramarine and burnt sienna. The greys and browns on the buildings were created with various mixes of the sky colours. When I got to the foreground, I echoed the sky colours once again, to create continuity and harmony.

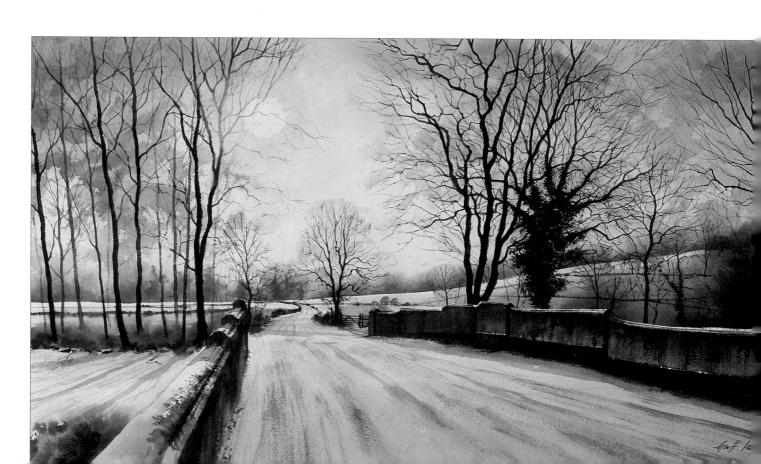

Winter in Halldale Woods

33 x 44cm (13 x 17¼in)
Because of the mass of tall trees in this scene, we do not have an uninterrupted view of the sky. Nevertheless it is the afternoon glow emanating from the sky that gives the painting light and atmosphere. The warm glow was created from a wash of aureolin and vermilion which softens into a warm grey mixed from vermilion and cobalt blue. This in turn softens into a cooler grey, containing more blue. The same grey mixtures are then used to create the all-important shadows, which steadily become warmer and redder towards the foreground. I used white gouache to indicate a light dusting of snow on the bark of the big tree on the right, on the tops of the stones in the bottom left and on some twigs and branches.

Opposite
Bridge at Rowsley

65 x 36cm (25½ x 14¼in)
In this winter scene we are looking across a road bridge into a weak, wintery sunlight, which is silhouetting the skeletal forms of a variety of trees. The whole painting was created with just four colours: cobalt blue, neutral tint, burnt sienna, and light red. To create a soft edge round the circle of the sun, I first of all wet the paper with clean water, and literally dropped a droplet of masking fluid from the end of a brush into the wet background, without touching the paper with the brush. I then mixed three thin washes: light red, cobalt blue and neutral tint, before rewetting the whole of the sky area. The light red wash was then painted in a circle around the sun, fading it out before introducing the cobalt blue and neutral tint washes. I then introduced a slightly stronger mix of cobalt blue with neutral tint and a hint of light red, to suggest the misty shapes of distant trees on the horizon. When the sky was dry, I removed the masking fluid to reveal a circle of white paper. This circle did not have as soft an edge as I would have liked, so I faded it with clean water on a damp brush.

Evening Light

On a recent day trip to Venice we were waiting by the Grand Canal at the end of the day for the return journey. The light was fading fast but the colours in the sky were inspiring, so I took advantage of the wait to take some photographs. When we are out and about, I usually have my camera with me and it is rare for me not to be looking out for potential painting subjects. I have not rendered the buildings strictly as silhouettes as I wanted to indicate some reflected light and detail, but I tried to make sure that the limited colours used for the building details were mixed from the same basic palette as the sky.

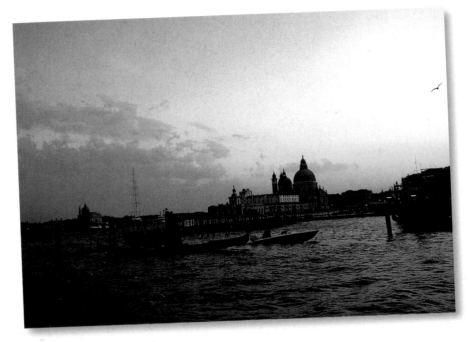

The reference photograph.

The preliminary sketch.

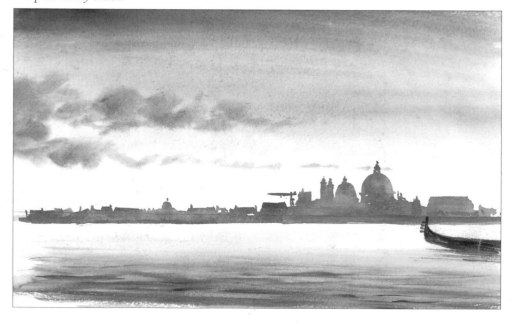

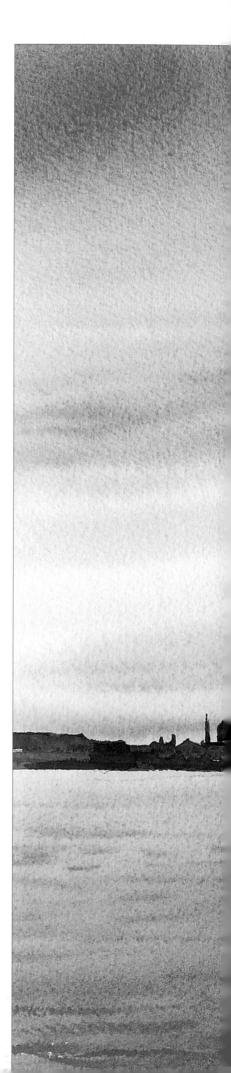

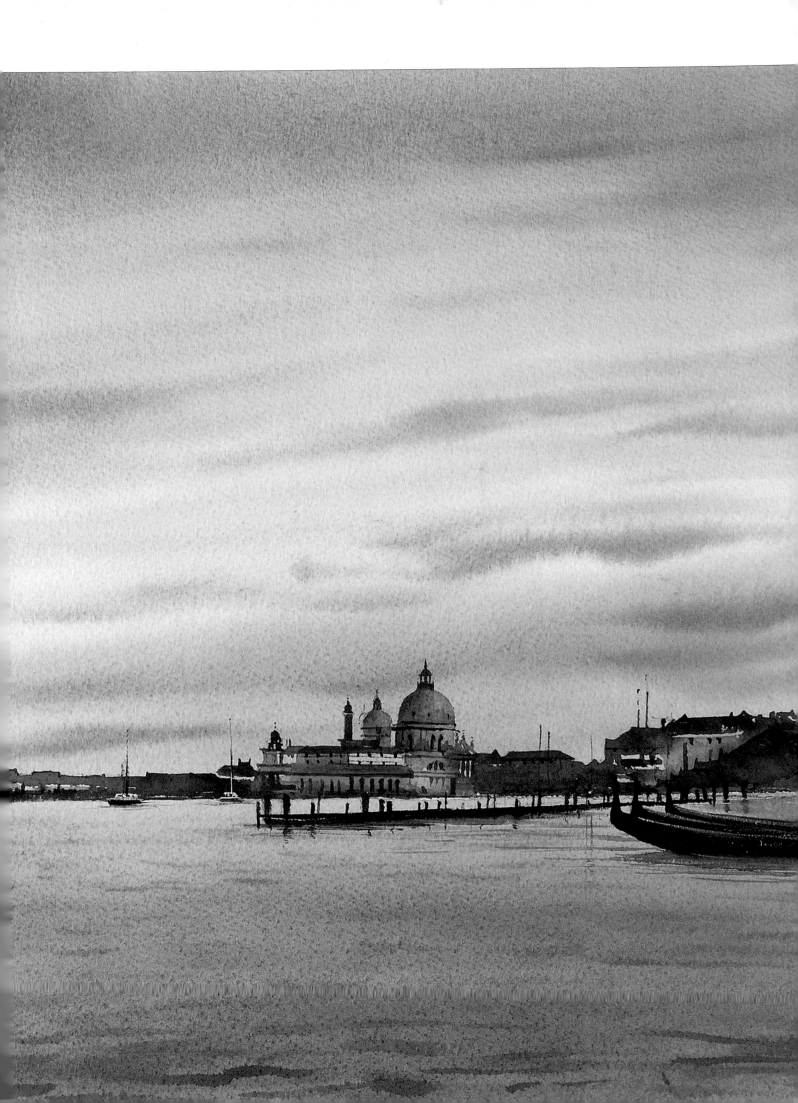

1 Draw the scene and apply masking fluid where the distant buildings meet the water. As always when working wet in wet, prepare your washes in advance: cobalt blue and rose madder for purple; aureolin; aureolin and burnt sienna for orange; rose madder; burnt sienna; and neutral tint and rose madder for cloud.

2 Wet the sky area with a clean 2.5cm (1in) flat brush, going over the buildings. Paint strokes of aureolin horizontally.

3 Clean the brush thoroughly and apply the cobalt blue and rose madder mix from the top. Do not merge it with the yellow or it will make green.

4 Pick up the orange mix and paint streaks with the flat brush on its side.

5 Paint rose madder streaks near the horizon and near the top of the sky.

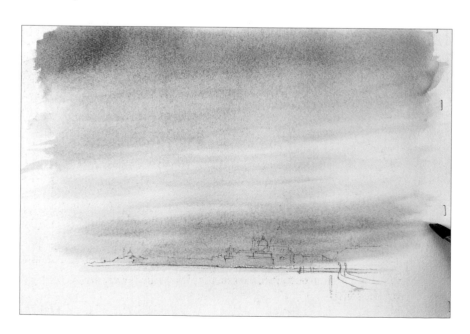

6 Add burnt sienna at the bottom of the sky near the horizon.

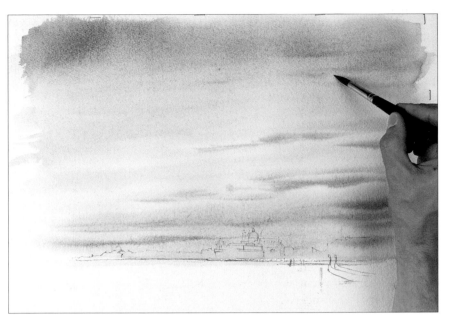

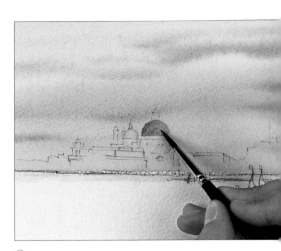

7 Pick up the neutral tint and rose madder mix with the no. 10 brush and create streaks of cloud with the very point of the brush. Allow the sky to dry.

8 Some of the sky colours should be reflected in the dome. Use the no. 6 brush and cerulean blue to paint the left-hand side of the dome, then add aureolin and rose madder on the right. The colours should soften and merge on the paper.

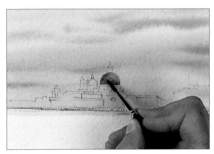

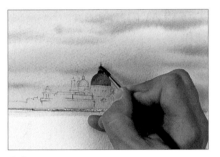

9 Drop in the purple mix from the sky washes and blend it in.

10 Mix a grey from burnt sienna, rose madder and cobalt blue and use the tip of the brush to paint the details at the top of the dome. Allow the colour to run down into the rest of the dome.

11 Paint the second dome in the same way. Add water on the right-hand side to imply highlights. Drop aureolin and rose madder in to the right-hand side of the larger dome.

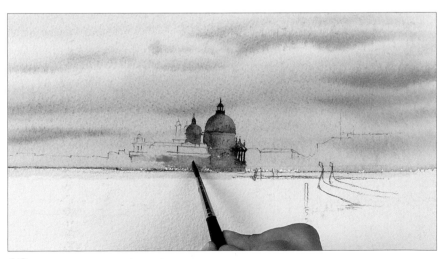

12 Change to a no. 4 brush and paint building details, leaving bright highlights.

13 Drop in aureolin and rose madder so that the glow of the sky appears to be reflected in the buildings.

14 Paint the red roof and the tower with burnt sienna and cobalt blue.

15 Use neutral tint to paint further details such as little arched windows on the dry dome.

16 Paint windows on the building on the left, then paint the roofs on the right with burnt sienna and cobalt blue. Paint the walls with dilute burnt sienna.

17 Drop in rose madder and then purple to reflect the sky colours.

18 Work towards the right, painting roof shapes in the dark brown mix. Leave gaps to suggest rooftops catching the light. Drop in some cerulean blue to vary the colour of the highlights.

19 Use the brown mix to drop more roof shapes into the blue, then drop in rose madder and burnt sienna to warm it up.

20 Drop in a little neutral tint at the bottom of the right-hand buildings. Then use the same colour to paint little arches at the base of the domed buildings.

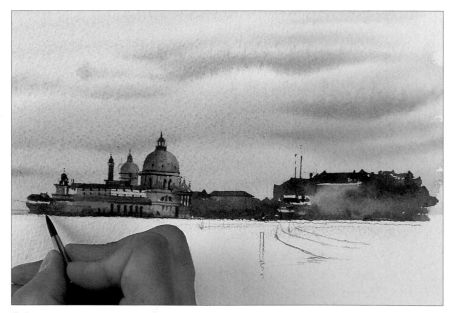

21 Paint the little dome on the left of this section with rose madder and burnt sienna. Use cobalt blue and rose madder to suggest shadow on the buildings. Paint more buildings down to the water's edge with burnt sienna and cobalt blue. Try to keep a level, neat line where the distant buildings meet the water's edge.

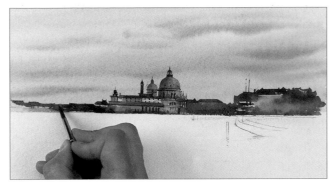

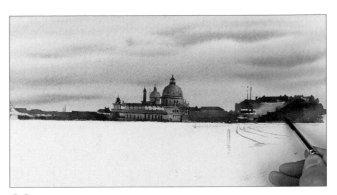

22 Paint more rooftops going towards the left-hand side using burnt sienna and rose madder, then add cobalt blue and burnt sienna lower down.

23 Paint the area on the right with a strong mix of neutral tint and rose madder.

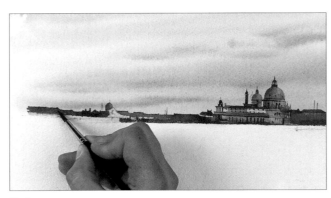

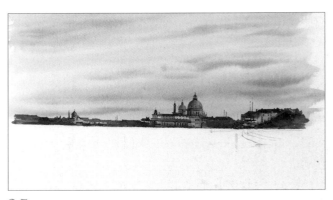

24 Use the point of the brush to paint masts. Paint the dome on the left with cerulean blue, then add grey on the shaded left-hand side and burnt sienna and rose madder lower down. Carry on to the left using burnt sienna and cobalt blue to describe the shape of rooftops.

25 Paint down to the waterline with rose madder and burnt sienna. Paint the building in front of the blue dome with a thinner mix of cerulean blue. Using neutral tint and a no. 4 brush, add suggestions of architectural details such as windows and the edges of roofs.

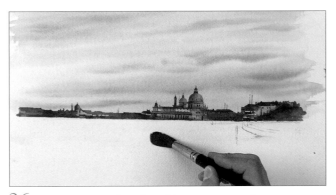

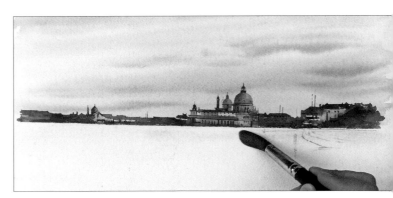

26 Take the no. 16 brush and begin to paint the water, which should reflect the sky colours but upside down. Begin with horizontal strokes of aureolin.

27 Next paint aureolin and burnt sienna close to the waterline.

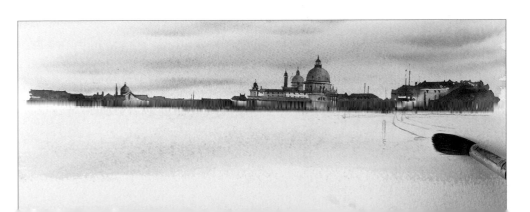

28 Working rapidly, add horizontal strokes of rose madder.

29 Add more aureolin and burnt sienna, then more purple mixed from cobalt blue and rose madder.

30 Add more rose madder in the foreground, working the colours together horizontally so that they merge.

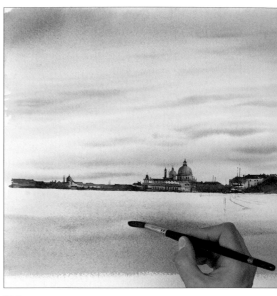

31 Paint streaks of neutral tint and rose madder with the no. 10 brush for cloud reflections.

TIP

When painting water, keep stepping back to look at the effect so that you do not overwork the area.

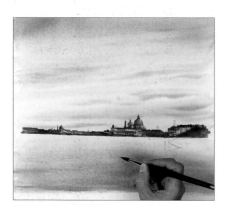

32 Mix cerulean blue and burnt sienna to create bluey-grey ripples in the foreground water. Use the tip of the brush to paint smaller ripples further back.

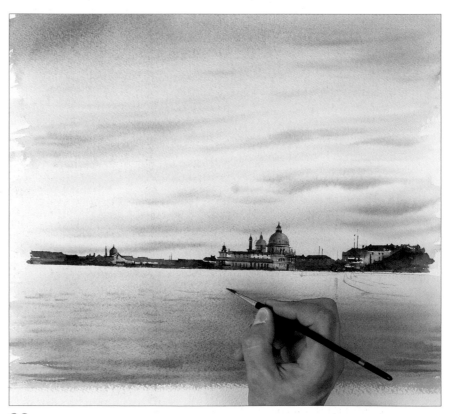

33 Paint more definite ripples on the foreground area as it begins to dry. Change to a no. 4 brush and a mix of cerulean blue and burnt sienna, and paint smaller, finer marks further back. Allow the painting to dry.

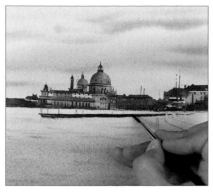

34 Draw in the jetty in front of the main dome. Mix neutral tint and burnt sienna to make a rich, dark brown and draw in the lines with a no. 4 brush.

TIP

I was not sure whether to include this jetty or not. If you want to leave your options open, do not draw any elements you are unsure of. Once you have painted over a drawing, the paint seals it and you will be unable to erase it.

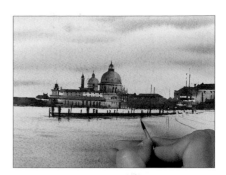

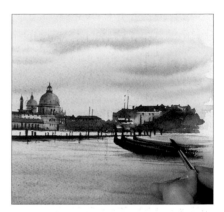

35 Paint the reflection of the jetty underneath with cerulean blue and burnt sienna, softening it in a few places with a damp, clean brush. Use the brown mix to paint posts and their rippled reflections.

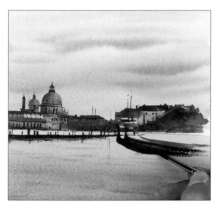

36 Mix cerulean and cobalt blue to paint the gondola covers, then use the dark brown for the gondolas themselves, allowing the brown to merge with the blue.

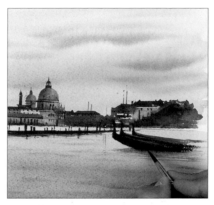

37 Use clean water and the no. 6 brush to soften the dark brown into the water, creating the gondolas' reflections.

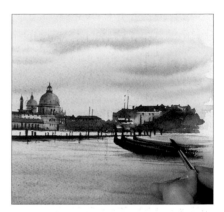

38 Paint the jetty as it continues behind the gondolas. Add a touch of rose madder to complete the water beyond the boats.

39 Add finishing touches using white gouache. Mix a touch of rose madder with the gouache to make ripples under the gondolas and jetty. Add aureolin to paint the distant boats so that they stand out against the dark background. Complete the boats with the dark brown mix. Suggest reflections under the boats using cerulean blue and burnt sienna. Add cerulean blue to white gouache to suggest the light catching the gondola covers.

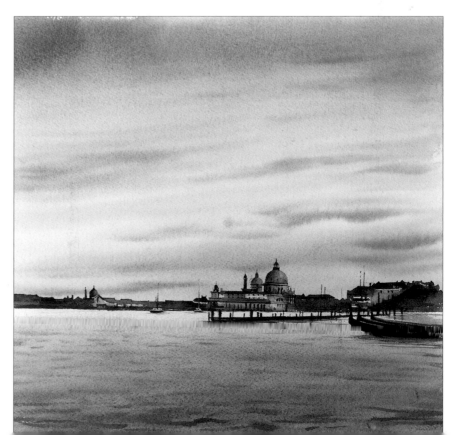

Brancaster Staithe, Norfolk

41 x 31cm (16¹/₈ x 12¼in)
This painting is all about light. The sky is quite simple with washes of quinacridone gold, cerulean blue and cobalt violet floated into a wet background. I have taken care to repeat these colours in the sandy foreground and middle distance, to give the painting harmony. This is not strictly accurate, as the real colours are browner and muddier, but beware of being too accurate in a situation like this, as muddy colours can look dull and flat. It is much better to create a pleasing painting with a feeling of warm light and atmosphere.

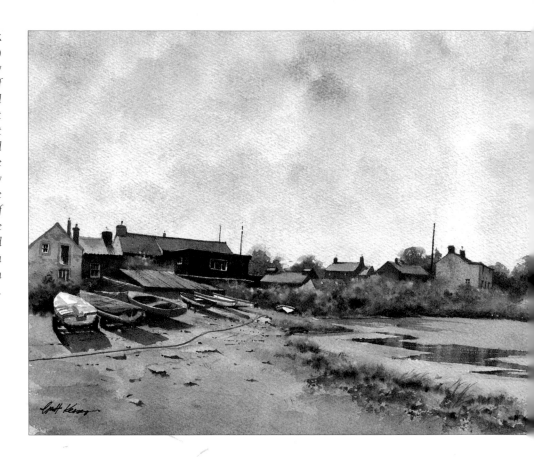

Burnham Overy Staithe

In this evening scene on the Norfolk coast, I have tried to capture the intensity of the light, using the contrasts created by almost clean white paper for the middle ground, surrounded by some quite heavy darks. I painted the sky with just three washes – quinacridone gold, burnt sienna and cerulean blue. The darks are a mixture of burnt sienna and cobalt blue, with a touch of aureolin added to make the olive green colour used for the suggestion of grass in the right-hand foreground, and at the base of the building on the left. The man-made colours on the figures and boat hulls add a touch of contrast and variation.

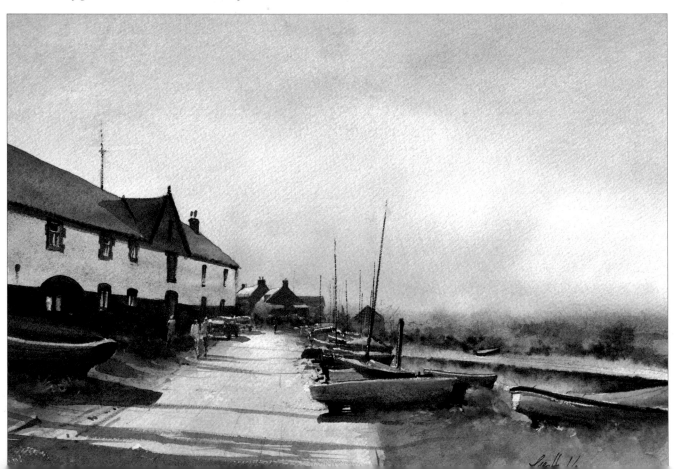

The Old West Station, Tunbridge Wells

23 x 30cm (9 x 11¾in)

This painting is all about warm light and shadows. I came across the scene crossing the road to a car park after a day in the photographer's studio, producing this book. You should always be on the lookout for potential subjects. I used quinacridone gold for the glow in the lower part of the sky, adding a touch of rose madder in the middle and finally a touch of cerulean blue with rose madder to create the grey at the top of the sky. It was very important to reintroduce these colours later in the foreground and middle distance shadows.

The rich, dark greens are also very important as they contrast with the brighter areas – note the splash of light in the bushes on the lower left. The dark green was mixed from viridian, ultramarine and burnt sienna, contrasting with the bright area created from lemon yellow and Naples yellow.

Index

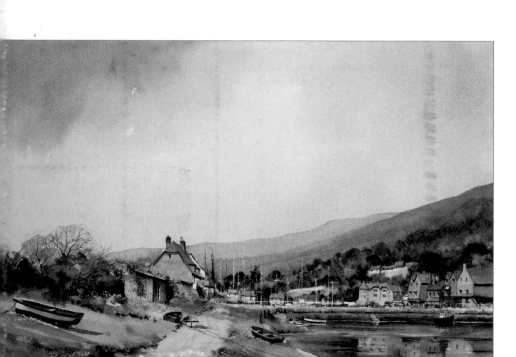

Porlock Weir, Somerset

45.7 x 30.5cm (18 x 12in)
This is quite a busy subject, with plenty of interest and detail. I deliberately kept the sky simple, so it acted merely as a backdrop. I laid a thin wash of raw sienna on to a wet background in the bottom of the sky, followed by a slightly stronger wash of cobalt blue with a touch of rose madder at the top. I angled the board to let the paint run downhill slightly, and let it dry.

I wanted to create an impression of reflections rather than a mirror image, so I dragged the wet colours down with vertical strokes, using a 1.3cm (½in) flat brush.